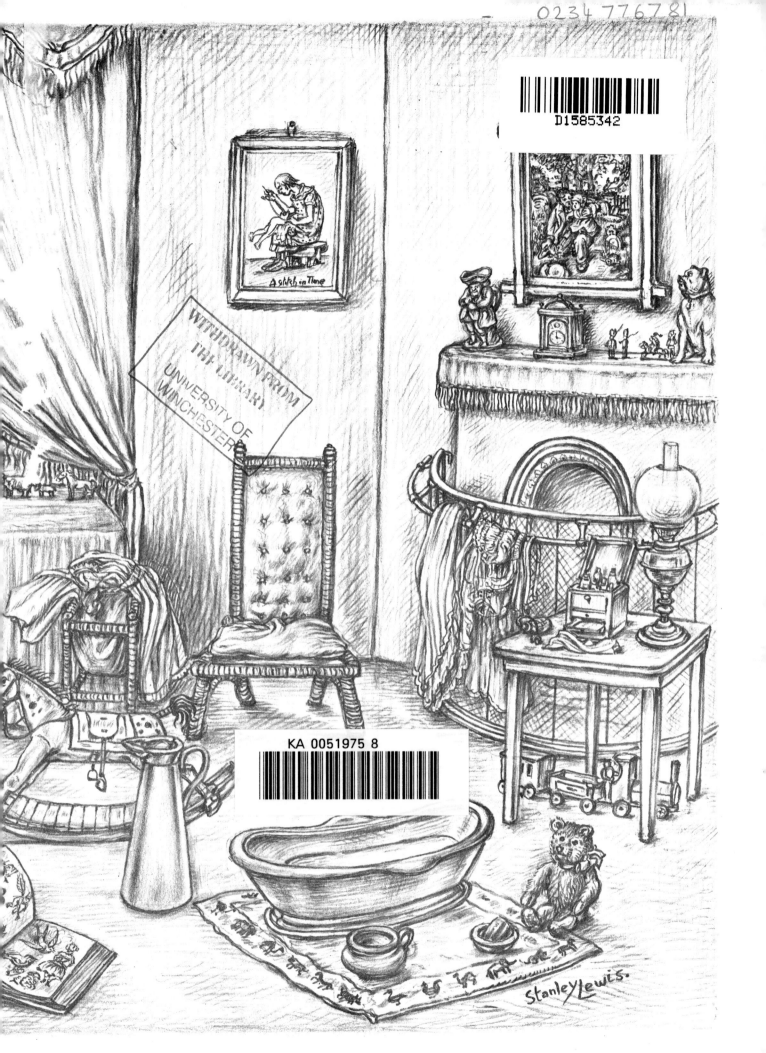

A Stitch in Time

Stanley Lewis.

INFANTILIA

The Archaeology of
the Nursery

Also by

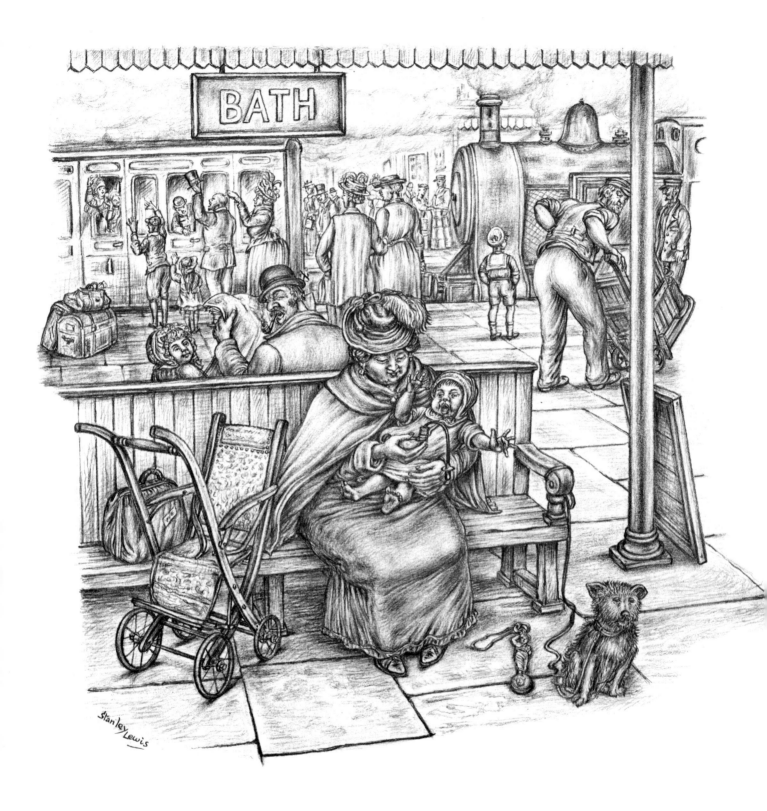

INFANTILIA

The Archaeology of the Nursery

by

ARNOLD HASKELL

and

MIN LEWIS

illustrated by

STANLEY LEWIS

London
DENNIS DOBSON

First published in Great Britain in 1971
by Dobson Books Ltd., 80 Kensington Church Street, London W8
Filmset and reproduced by Photoset, London
Printed by Latimer Trend & Co. Ltd., Whitstable
ISBN 0 234 77678 1

To
MARY VIVIAN
with love
A. L. H.
and
M. and S. L.

ACKNOWLEDGEMENTS

The authors wish to thank the following for permission to quote from the works mentioned:

The Hardware Trade Journal for the article on Perambulators and Mail-carts from "The Workshop Review" in the issue of March 1900.

Pram World and Nursery Times for the excerpt from "The Silver Cross Story" published in *The Perambulator Gazette and Nursery Trader* of November 1964.

Public Affairs Press for passages from *Toys in America* by Marshall and Inez McClintock.

The Royal Society of Arts for excerpts from a paper given by Samuel J. Sewell entitled "The History of Children's and Invalids' Carriages" and published in Vol. 71 of The *Journal of the Royal Society of Arts*.

The Times for the article on "The Royal Pram" published in the issue of December 8th, 1948.

CONTENTS

Parts I, II, and III by Arnold Haskell
Part IV by Min Lewis

References in text margins are to illustrations elsewhere in the book.

NOTES ON THE ILLUSTRATIONS

The Late Victorian Nursery designed by the Hon. Mrs. Douglas Vivian for *The Age of Innocence* Exhibition at the Holburne of Menstrie Museum, Bath 1969-70. All the exhibits were loaned. *Endpapers*

At the railway station. *Frontispiece*

A Gibson medicine spoon. Invented 1827. Britannia metal. Late nineteenth century. *Page* 18

The dummy. This has taken the place of the elegant coral teether with its magic properties. A witty writer, Simon Levin, in his wise and amusing *A Philosophy of Infant Feeding* says, "Amateur Egyptologists will recognise at once the startling similarity to the *ankh*, the Ancient Egyptian symbol of life." He goes on to say that many of the gods and pharaohs seem to be holding a large dummy; a strange quirk of fate. 18

After a drawing in *Punch*. Late nineteenth/early twentieth century. "The Festive Season. *Precocious Infant:* 'Help yourself and pass the bottle.'" 21

The human touch. 23

Feeding bottles in underglaze blue transfer printed earthenware commonly known as "Staffordshire blue", a method first used in the mid-eighteenth century. These are rarely marked. Dates *circa* 1830-40. The plain white or cream models are earlier. Spode made some in 1810.
(bottom) Unmarked. Longitudinal ribbing. Length $7\frac{1}{2}$ inches.
(centre) Impressed "Wedgwood". Medium blue. Length 6 inches.
(top) Marked in blue "Copeland late Spode". Very deep blue. Length 7 inches. 24

Mellin's Food advertisement, 1880. 28

The cow's horn as feeder; taken from a thirteenth-century miniature. Some have been found with clay teats round the aperture. It was recommended by a physician, Dr. Armstrong, as late as 1770. 31

Papboats. The papboat was introduced in the early eighteenth century and flourished until the mid-nineteenth century. Silver ones were made by the leading silversmiths. They only fetch prices of over £50 when the maker is well known or the workmanship exceptional.
(left) Silver gilt with applied cast decorative border. London 1817. Makers: Solomon Hougham, Solomon Rayes, John East Dix. $5\frac{1}{2}$ inches long; $3\frac{1}{4}$ inches wide.
(centre) Silver; of typical form, engraved with floral decoration. Gilt interior. London 1845. Inscription on side "HAK to MENB". Makers: Joseph and John Angell. $4\frac{3}{4}$ inches long; $2\frac{3}{4}$ inches wide.
(right) Silver. London 1793. Maker: Samuel Massey. $4\frac{1}{2}$ inches long; $2\frac{1}{2}$ inches wide.
(below) Horn; shell-shaped. Scottish, late eighteenth century. 4 inches long; $2\frac{3}{4}$ inches wide. 32

Earthenware papboats from 1830 onwards. These are common and inexpensive, though models by Wedgwood or Minton fetch up to £15. It is debatable whether those with covers or handles were for infant or invalid use. The size is certainly the determining factor.

An eighteenth-century feeding bottle and bubby pots.
 (left) Pewter feeding bottle. English *circa* 1745. Height 6 inches; capacity about 8 fluid ounces. A pewter feeding can was first used in Germany in 1480.
 (centre) Bubby pot. Blue transfer. *Circa* 1780. Height $5\frac{1}{2}$ inches.
 (right) Bubby pot. Creamware. *Circa* 1780. Height $4\frac{1}{4}$ inches. Both bubby pots probably by Wedgwood.

Staffordshire blue and white pottery bottle. *Circa* 1830-40. Unmarked. Length 7 inches.

Reverse side of the same bottle.

Staffordshire blue earthenware feeding bottle with original stopper. *Circa* 1830. Height 7 inches.

Glass feeding bottle, handmade. Inspired by the cow's horn. *Circa* 1840. Length 8 inches.

Three handmade glass feeding bottles of differing design. *Circa* 1850-60.

Two important glass bottles.
 (left) The Alexandra feeding bottle. Outlawed in Buffalo, U.S.A. (which saved lives) and attacked as lethal in the *Journal of the American Medical Association*, August 5th, 1899. It persisted in England until around 1915.
 (right) The Allenbury's Feeder that replaced it, earning high praise in *The Lancet*, June 6th, 1896. The embossed plough is associated with the address of the makers, Plough Court. This type of bottle was replaced by the upright in the 1950's.

Embossed designs from American glass feeding bottles—"Pop art" in the nursery. *Circa* 1912-1925.

Past and present.
 (left) Unglazed earthenware feeding vessel. Roman; found in the Roman cemetry, Bishopsgate Street, London and now in the Guildhall Museum. *Circa* A.D. 200.
 (centre) Black terracotta feeder. Italiote, from a Greek colony in Southern Italy. *Circa* A.D. 200. British Museum. Length $6\frac{7}{8}$ inches.
 (right) The Simpla, modern feeding bottle; a return to the line and form of the elegant glass and pewter flask of the German 1800's. Glass may soon be as out of date as horn, pewter, earthenware or wood.

Stafford blue pottery feeders. *Circa* 1830.
 (left) Length $6\frac{3}{4}$ inches.
 (right) Length 8 inches.

Three silver rattles with teething sticks.
 (left) Silver. Hexagonal ivory stick. Two tiers of four bells. George I. *Circa* 1720. Engraved with the initials "E.S.". Length 6 inches.

(right) Silver with coral stick; of pierced baluster form containing bell. Birmingham. *Circa* 1812. Maker: Joseph Taylor. Length 4½ inches.

(below) Silver rattle and coral stick. George I. *Circa* 1720. Initials "J.G." engraved on whistle. Length 5¼ inches. The restrained style of the George I rattles is in striking contrast to the rococo that followed. They are superbly balanced.

Poupard or *Marotte*. Ivory handle. French. Early twentieth century.

Teething sticks.

 (left) Gold and coral. George I. *Circa* 1720. Marked with owner's initials "W. M.". Maker: R. F. Length 5 inches.

 (left centre) Silver gilt and coral. George II. *Circa* 1740. Length 4⅙ inches.

 (centre) Gold and coral. Charles II. *Circa* 1680. Length 2½ inches.

 (right centre) Silver and coral. Decorated with bright cutting. *Circa* 1790. Length 3¼ inches.

 (right) Silver gilt and coral. George III. Length 5½ inches. Teething sticks or gum sticks are scarcer than rattles and seem to have become obsolete during the first quarter of the nineteenth century, to be replaced by ivory or bone rings. In America in the eighteenth century and after a wolf's tooth bound in metal was a favourite device. Their resemblance to Southern Italian phallic amulets is obvious from these drawings.

Silver rattle with coral stick. Birmingham 1852. Marked with initials of original owner, "J.T.R.". Makers: Hillard and Thomason. Length 5½ inches. This model has charm and originality but is not of outstanding craftsmanship, as one can see from the ring that held it to a chain or ribbon, always an important test of quality. At this period only Rawlins and Sumner remained in the great tradition. George Unite was prolific and occasionally imaginative but not of the front rank.

Gold and silver gilt rattles.

 (left) Gold rattle. Four bells in two tiers. Embossed and chased with rococo motifs. Coronet engraved on whistle lip. 1740. Length 6 inches. The size of a rattle is important.

 (centre) Silver gilt with bands of silver. Two tiers of five bells. London 1771. Maker: Walter Tweedie. Length 6 inches.

 (right) Silver gilt. Eight bells in first tier, four in second. Heavily embossed and chased with flowers, scroll work and palmettes. Typical of rococo revival. Birmingham 1827-8. Maker: Joseph Willmore. Length 6½ inches.

Two rattles.

 (left) Silver. Probably Peruvian. Length 6½ inches. (Illustrated in *Collector's Guide*, February 1969.)

 (right) Turned ivory. Length 6 inches.

Cimaruta. Southern Italian silver amulets. Traditional. Date unknown, probably mid-nineteenth century.

Penny rattles.

 (left) Celluloid. Early twentieth century. Length 6 inches.

 (centre) Britannia metal. Early twentieth century. Length 2 inches.

 (right) Tin. From the U.S.A. Early twentieth century. Length 6 inches.

16

I

INTRODUCTION

by

ARNOLD HASKELL

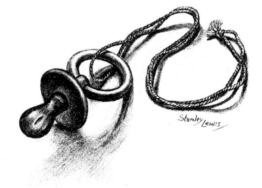

Some people are born magpies, collectors from their earliest days. There are many involved psychological explanations for this, interesting in themselves though they do not concern us here. As we shall see, the nature of the object collected often depends upon chance but it seems obvious that no one would collect *infantilia* who was indifferent to babies, soldiers without an interest in military history, or firearms without a suppressed aggressive tendency. As will be seen, Min Lewis's "addiction" to perambulators started at the age of four in the excitement of a Christmas morning. The acquisition of each p. 70 new pram reawakens the memory of that Christmas feeling.

The latest motive, collecting for investment, is only another method of dealing on the stock exchange and one that in the long run defeats the serious collector by so raising the prices that he can no longer continue. Nevertheless, there is a very inflated ego as well as an inflated price when an object increases in value.

Nowadays many objects are being collected that were in ordinary domestic use less than a century ago and that, when they had served their purpose, were thrown out with the rubbish or that found their way into some trunk in the attic. Fortunately some of these objects were kept for sentimental reasons with no thought of possible future profit; dolls and toys for instance. Today they are collected and even paid the supreme compliment of forgery. No wonder when a doll made by the firm of Bru in the late nineteenth century can be sold at Christie's for £900 or over. There are a score of well illustrated and scholarly books on doll and toy collecting. A tin toy costing a few pennies may be sold for as much as £25, a model train can fetch hundreds.

Some of these objects, the dolls in particular, are minor works of art. When in their original costume they are of considerable interest as a record of fashion. Dolls houses in such a collection as Mrs. Graham Greene's are a guide to furniture and architecture. Such *juvenilia* also include boys' interests. Model ships, soldiers, trains and aeroplanes are collected and surely played with by elderly dons as well as gaining daily in value and interest. They are far beyond the purse of the average collector though they may still easily turn up by chance in some forgotten trunk.

My own rules in collecting, and I have been a magpie since childhood, apart from acquiring the bronzes and paintings that, alas, I can no longer afford, are the following. The object must have some aesthetic quality. It must be of sociological interest, shedding some light on the habits of the past. It must not have been studied to such an extent that nothing any longer remains to be discovered. It must be in as near perfect condition as possible, unless it is so rare that this is impossible. The final rule is that it must be scarce, but comparatively inexpensive when found, so that every visit to a junk shop brings the excitement of the chase. Collecting of this kind may be considered something of a sport. I have on many occasions jumped off a bus with considerable risk to life when I have glimpsed some object in a shop window. One begins to have a sixth sense about these things. Sir Martin Conway wrote an interesting work with the appropriate title, *The Sport of Collecting* though he was dealing with the "big game" masterpieces.

Curiously enough, though my life has been spent among dancers, I have never collected dance material, partly because with notable exceptions the translation of one art into another is rarely successful, partly because I have been over exposed and it

19

was all too easy. I accumulated many things and gave them away. I regret it now that they have soared in value and that I myself have become something of an antique.

The question of space is of course important but that is a matter for each individual. Vintage cars and traction engines have their devotees. A room should not be completely cluttered up with objects. My house overflows and I have ignored my own advice. To be truly rewarding items must be well displayed. A great deal of the pleasure of collecting lies in the arrangement and rearrangement of one's "treasures". Also, there are the by-products of such collecting, in themselves well worth a search; the photographs, clippings and old catalogues that are the instruments for dating one's finds. Early volumes of *Punch* and *The Illustrated London News* are a mine of information. Incidentally, their admirable wood engravings are more revealing of detail and have far more charm than the photograph that can lie so abominably.

The three objects dealt with in this book belong to a small subsection of *Juvenilia* that I have christened, *Infantilia*. They certainly fulfil the set of rules that I have laid down for my own collecting though the prams require space. The authors have been fortunate in being able to draw upon their own extensive collections for their information and their illustrations.

Perambulators, rattles and feeding bottles are familiar enough objects all of which have played some role in our lives. Rattles and feeding bottles date back into pre-history. There is, however, not a single book dealing even superficially with any one of these three common domestic objects. It is difficult to date a perambulator accurately though it is of such recent usage. The word "perambulator" is not mentioned in the *Encyclopaedia Britannica*, neither is "rattle" and though there is an article on child care there are no historical data on feeding devices. No book on silver devotes even one section to rattles though they were designed by the greatest silversmiths of the day. Feeding bottles are well covered but only in specialised books and articles on paediatrics, difficult to obtain, and even here there are blank periods and debatable points. Very few people would immediately recognise a feeder over a hundred years old if it lay on a shelf in front of them as I saw in a recent exhibition. Silver papboats are known to collectors of silver but many of these have been converted into sauce boats or are sold as sweet dishes and ash trays. In the large literature on silver they receive very brief mention. In the case of the earthenware and glass ones it is often hotly debated whether some were for invalid or infant use. Even the bottles of fifty years ago, though there must be many about, are comparatively hard to find. They were undecorative and as such were certainly thrown out when no longer used, as were the ginger pop and soda water bottles now also collected.

I was first confronted with these problems—hence my appearance between these covers—when I was helping the curator, Dr. Mary Holbrook, to arrange the catalogue for an exhibition, "The Age of Innocence", that I devised for the Holburne Institute* at the Holburne of Menstrie Museum, Bath 1969. The research, the word is a little pompous, was fascinating for its own sake and the wide interest shown by the public in these objects surprised me, though on reflection this was not so astonishing. The exhibition had a nostalgic quality, particularly well summed up in the Hon. Mrs. Douglas Vivian's admirable reproduction of a cosy Victorian nursery; illustrated here as end papers. One very old lady expressed heated indignation at its untidiness, showing at

* This institute is run in connection with Bath University.

20

any rate that she took it seriously and was ready to give nanny a stern reprimand.

The greatest reward of any type of collecting, one that I have not yet mentioned, is meeting fellow enthusiasts. It was through this exhibition that I really came to know Stanley and Min Lewis. Perambulators that I borrowed for the exhibition introduced us in the first place but we soon found a number of tastes in common, especially in the poetry and person of Dylan Thomas about whom Min Lewis has written so eloquently, and in painting, drawing and sculpture. In Stanley I found an artist not only skilled in draftsmanship but one whose work possesses a warm humanity and a sensibility divorced of all sentimentality. I have spent many entrancing hours looking at volumes of his sketches of people and objects. Both Stanley and Min possess a rare feeling for fine craftsmanship and their collection of "vintage" perambulators, which I suggested they form into a museum, delights them for the beauty and ingenuity shown by these miniature carriage builders of the past.

Only a few illustrators have depicted prams. I can think of one sculptor, Jacob Epstein in a bas-relief for the Lewis building in Liverpool. In the films one of the most moving shots is the pram tumbling down the stairs in *The Battleship Potemkin*.

p. 92

Stanley's drawings that illustrate this work are not only more accurate than any photograph they are also a reflection of his sensitive reaction to fine artefacts. Here in this volume—as in the enchanting painted mural that sets off this notable collection in the museum at Beckington—he shows the objects not only in minute detail but also in the context of their period and use and his comments on their design add greatly to the interest. Many of his sketches, drawn years before the first pram was collected, are of babies in their prams, being nursed or toddling and some of these are reproduced here as a human background to our subject. How quickly they have become documents of "nursery archaeology", often before the baby in the pram is pushing her own children down the street.

The perambulator collection is open to the public but the rattles and feeding bottles enjoy a certain privacy. They are fragile. Collectors are, with rare miserly exceptions, essentially extroverts, willing to share their enthusiasm and their pleasures, but when sources and prices are concerned they have their secretive side. Already in the past few months prices have risen as more collectors, especially in the United States, have joined in the hunt for *Infantilia*. American and Canadian paediatricians in particular are great enthusiasts and extremely knowledgeable in such collecting in which they have shown themselves to be scholarly pioneers to whose researches I am greatly indebted.

This book, dealing as it does with familiar domestic objects, is one that must surely interest a wide public, everyone who remembers his childhood or has children. It stresses the importance of the well-designed object, it teaches us to see and to understand the development of objects that, because they are functional, we tend to take for granted. Its authors, in unearthing the archaeology of the nursery, have had to explore medical and social history, the manufacture of silver, glass and earthenware and the simple mechanics that have gone into the making of a well-sprung pram; there is a collection of prams in the Science Museum at South Kensington. They have also learned the revealing fact that, in many cases, more is known about the distant past than of last century.

I would make a strong plea to manufacturers to research into the history of their own products, even if this is not for general publication. It seems to me of special interest to delve into the period when the machine-made, or partly machine-made object began

22

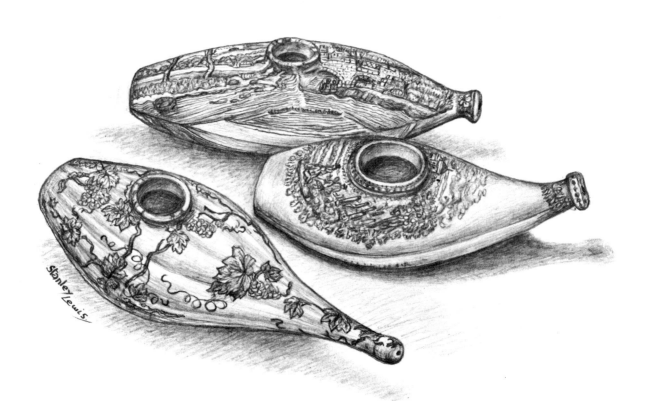

to become mass produced. One would, for instance, like to know why the pottery feeding bottles of the early nineteenth century were so beautifully decorated. The blue under-glaze transfer printed earthenware first used in the 1760's, "the poor man's porcelain", was a British product and a big export. Was this a form of presentation to appeal to a wider public or was it because these firms of distinguished potters were incapable of producing a shoddy article? This transfer printing was, of course, a cheap form of decoration largely carried out by children and the transfers were already to hand. However, it must have taken considerable ingenuity and time to fit the design to the boat shape. In the finest ones it is so well done that one would think that the transfer was specially made for the purpose. Thomas Minton was a pioneer in the making of these designs. It would be interesting to know the number produced. It is doubtful whether such information can now be found. This book may serve as a stimulus, though as I have discovered much of the information has gone forever. It is not even known exactly when the boat-shaped feeder came into general use.

II

FEEDING BOTTLES AND PAPBOATS

by

ARNOLD HASKELL

My sister, Mrs. Joe Gargery, was more than twenty years older than I, and had established a great reputation with herself and her neighbours because she had brought me up "by hand".

Charles Dickens. *Great Expectations*

And heigh-ho for a bottle tonight—
A bottle of milk that is creamy and white.
Eugene Field. "The Bottle Tree" from *Lullaby Land*

biberon: tippler, wine bibber
biberon: feeding bottle

Harrap's *French Dictionary*

For the next eight or ten months, Oliver was the victim of a coarse treachery and deception—he was brought up by hand.

Charles Dickens. *Oliver Twist*

MELLIN'S FOOD

For Infants and Invalids.

NOT FARINACEOUS.

TRADE MARK

Stanley Lewis.

It is the custom to bury an airtight container in the foundation of a building containing various articles in daily use. These are often a copy of *The Times* and a set of coins. Sometimes in the past there was mention of a baby's feeding bottle. The value of the first two for an archaeologist of the future is obvious, but I never understood and no one can tell me the exact significance of the bottle. Was it a symbol of the infancy of the building? What valuable information would it give in the centuries to come? I did not then know the great antiquity of the feeding bottle. Had I thought about it at all, I would have imagined that the first one was that long rubber-tubed atrocity of the late Victorian period. Any literature on the subject was confined to books and articles on paediatrics written by doctors for a limited and specialised public that had not then come my way.

I started my collection of *paediatric antiques*, to call it by a dignified name, as one so often does, by pure chance, though the fact of an unrealised ambition to be a paediatrician undoubtedly played its part. I saw on a junk shop stall, an attractive and graceful earthenware object with a blue transfer of a romantic period pastoral scene. It was priced at 30/–. The dealer was not quite sure what it was, he thought it might possibly be a feeding bottle. He had never seen one like it before. I bought it and put it on a shelf where, to my satisfaction, it was much discussed and admired. During the next three months I made two more finds; a fluted glass bottle with a tapered spout, a beautiful object in shape and design and a stubby pewter bottle that might have been taken for a pepper pot had the owner a friend of mine not known its usage. I followed this up by what I thought was a marvellous discovery, two multi-coloured bottles in an attractive uneven honey type glaze. They fitted the hand as snugly as a feeding bottle should and I bought them and put them in my cabinet. I now had five. Was it a collection yet?—I have yet to discover at what number a collection begins—at any rate I was on the way. A few days later I saw identical bottles in a well-known Bond Street dealers'. I went in to enquire. "Feeding Bottles?" "Perhaps, in a sense, these are whisky flasks, very popular last century", was the reply. It is true that even grown-ups "take to the bottle"; the French word *biberon* means both feeder and drunkard, but these corrupters were promptly removed from the innocence of my shelves and sold. Once again the collection was reduced to three. It now numbers over seventy; certainly by any standard a collection.

That enlightened collector Dr. M. E. Alberts of Des Moines, to whom I am so indebted for much information, also became a collector by chance when a patient brought him a flask to identify.

And so the collection began and with it some searching, I cannot dignify it by the name of research, into the history of the feeding bottle.

As a collection it fulfils in every way the rules set down in the preface; most of the objects have some beauty of form and design, they are certainly scarce, a year in which one finds from three to five is a successful one, and it becomes harder all the time, they are of very great sociological interest, they occupy little space, they are not too expensive. Finally, what has not been said in the preface and what every collector revels in, is the astonishment of those to whom they are shown. I have rarely met anyone who has even heard of such a collection. They are definitely "conversation pieces".

My first discovery was of the great antiquity of the feeding bottle. Feeding vessels

have been known from prehistory, the early stone age period. An earthen vessel, shaped like a fish, dating from around 2000 B.C., was found in a child's tomb in Babylon. I had always imagined that when the mother could not feed her infant, or was too smart to do so, he was entrusted to a wetnurse, probably a slave. Tacitus just before the fall of Rome commented on the sad fact that Roman matrons entrusted their babes to Greek slaves. In the Bible, the Iliad and the Odyssey there are references to the well-established profession of the foster nurse and the Greeks, for all their civilisation and culture, left their unwanted children to die of exposure. Yet Greeks and Romans used artificial feeding and only the Jews, among ancient peoples, are said never to have used wet nurses or substituted vessel for breast. Breast feeding was an obligation among women— Sarah presumably, at the advanced age of ninety, nursed Isaac!

The earliest feeding bottle, now in the British Museum, dates from the nineteenth/ eighteenth century B.C. This is earthenware and pot-shaped as are many spouted vessels of later periods and their use is often known through the fact that, like dolls and rattles, they were found buried in an infant's tomb. There are others whose usage seems obvious, breast-shaped with a spout that suggests a nipple.* One, from a south Italian Greek colony of the third century B.C., leaves no doubt as to its usage. It bears the inscription, *MAMO*. Of especial interest is a black terracotta feeder, also from one of the Greek colonies in Italy. It is functional and strikingly modern in design, boat-shaped with a spout and a hole that contains a strainer in the middle for pouring in the milk and regulating its flow and a convenient handle at the side. The practical Romans also introduced a glass feeding pot about the first or second century A.D. This was found at Colchester and is in the Castle Museum. There are also some rare and most attractive feeders in animal forms introduced by the Romans and still made of Majolica as late as last century. It is strange that no one has devised such a thing in modern times, though there is a whimsical rabbit-shaped plastic cover for keeping the feed warm.

It is extremely unlikely that any of these examples, though not as uncommon as might be thought, will find their way into the private collector's cabinet though any early spouted terracotta jug may have been used for infant feeding. There are also many earthenware vessels, again not so uncommon, that were at one time thought to be used exclusively for storing the oil for lamps. These, known as *Guttus*, are from Greek Colonies in Southern Italy and date from about the fourth century B.C. The spouts are sometimes in the form of an animal's head. They have a sieved hole in the middle for filtering the oil or milk and could certainly serve as feeders, though there are unmistakable feeders of the same period. Chemical analysis has shown that some of them once held milk. Any collector worth his salt must believe in miracles and pursue his subject to the end or rather the beginning, even if it be the stone age.

This is not a medical treatise and our concern is with the vessel and not with infant welfare, psychology or the food in the bottle. However, the dangers real and imaginery, of such artificial feeding must be mentioned, especially since the need for sterilisation was unknown until the time of Pasteur and the teat was usually a piece of rag stitched into the shape of a glove finger and stuffed with sponge or cotton waste, or a cow's teat, in-

p. 48

*I am now doubtful about some of these. The earthenware wine jug still used in Spain and dating from Roman times has a teat-shaped spout and a hole by which the flow of the wine can be regulated by a thumb placed over it. They may, of course, have also been used as feeders.

30

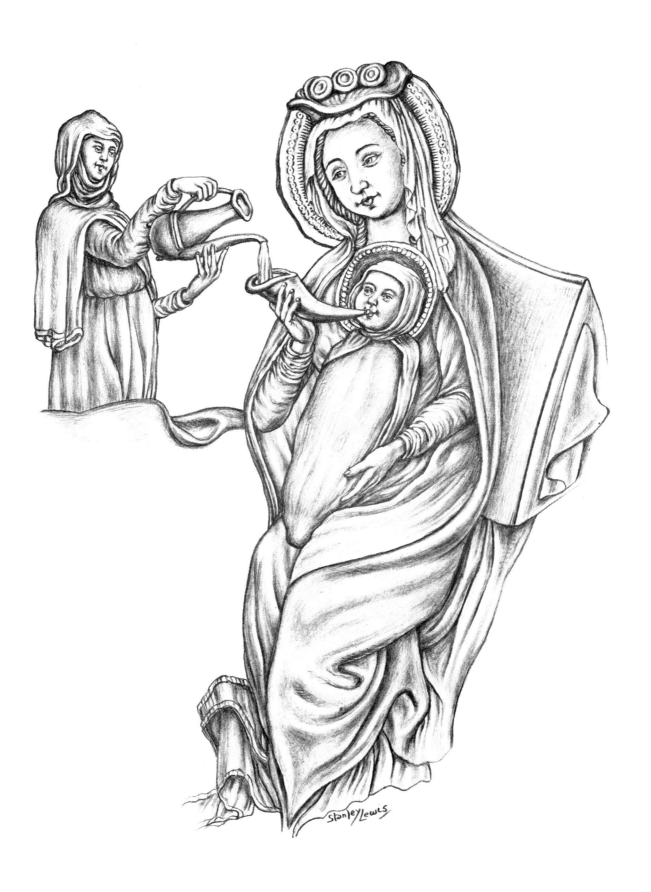

Stanley Lewis

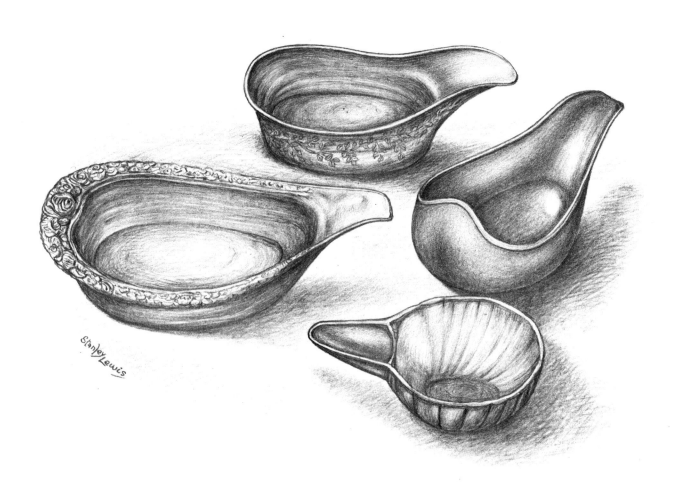

differently cured, ideal for the breeding of germs. Yet, in the minds of many until comparatively recent times, at least one terrible risk was avoided by the use of the feeder, that of the nursling inheriting the character of his foster-mother through her milk. This is continually stressed in books on the subject. For instance, a red headed nurse was said to induce a treacherous mind in her charge. One writer assures his readers that, if lambs are nursed by goats, they develop goat's hair. What then would happen to an infant nourished on cow's milk? There is little mention of artificial feeding in mediaeval times. As usual the Romans had been ahead of their day. Mother or wetnurse suckled the baby for the first three years of life; later this was reduced to two years and then a year. Infant mortality was high enough even with natural feeding, hand feeding was tantamount to a death sentence. In the mid- seventeenth century in England 2,000 babies died of gastro-enteritis during eight weeks of the hot summer months. In the early part of the nineteenth century hand feeding was fatal in London to seven out of eight children. The figures pale besides those in Dublin in the last quarter of the eighteenth century; 99·6 per cent of hand-reared babies died.

As late as Tudor times, specially designed feeding bottles were not known in England and cow's milk was not considered suitable, partly on account of superstition and partly because of the high degree of contamination in an insanitary world. We know only from old woodcuts that, from about the thirteenth century, a pierced and polished cow horn was sometimes used as a feeding vessel. A later refinement, about the last quarter of the eighteenth century, was a stitched teat of linen or leather stuffed with cotton waste, attached to the end. This was regarded as a great boon and as close to nature as possible. It has been suggested that the modern bottle owes its shape to the horn; this seems far fetched though I have a rare glass one from the early nineteenth century that is horn shaped. The shape of any domestic object is largely dictated by the ease of handling. The horn, unlike any feeding vessel before or since could not be set down on a table.

There was, however, an alternative to milk, a mixture called pap,* made up of bread and water or of cereals and Lisbon sugar, often mixed with beer or wine and occasionally chewed to the right consistency by the nurse. Sometimes a piece of Castile soap was added as a *digestif*. This was given in a *papboat* and many examples exist, made of wood, pewter, silver, earthenware, glass, bone or porcelain. These are shaped like sauceboats without the stem or handles, like spoons without the handle or like the larger and more familiar invalid cups, now also much collected. Some take the form of a bird with the beak as a spout. These held from one to three fluid ounces. The papboat continued in use right up to the second half of the last century. These are not difficult to find, though fine examples of silver, pewter or of Bow porcelain obviously command a high price. Many of the silver ones have been turned into sauce boats by the addition of handles and bases, some are used as ashtrays. In many cases, especially where there is a handle, it is highly debatable whether the article is a papboat or a cream or sauce jug. It could have served a dual purpose. Some of the early nineteenth-century cream coloured boats with scalloped edges made by Wedgwood are extremely attractive. They are not easy to find and fetch up to £20 when in perfect condition. Their original price was 2d. The later ones made in Staffordshire by Davenport, Minton, Spode and

*From the Scandinavian. An onomatopoeic word to echo the sound of an infant feeding.

other well-known potters are decorated with blue transfers with floral designs, rustic scenes or the familiar willow pattern. These stock transfer designs are also found on invalid cups and even on chamber pots. Such transfer printed vessels are often seen and are still comparatively inexpensive. Some of the later ones have covers over the spout and handles and only their size distinguishes them from invalid cups. Wedgwood made these until 1870. Papboats hold on an average up to 2 fluid ounces, their average length and width $4\frac{1}{4}$ ins. by 2. There are also ingenious spoons* with hollow handles and a cover to prevent the food being spilt. They were mainly used for giving medicines, certainly useful in administering castor oil. It is said that the nurse blew down the handle to make the mixture flow more easily. These date from the 1820's to the 1850's. Some have fine ivory handles. I have a cheap one in Britannia metal probably made by James Dunn of Sheffield that must have been sold for a penny. Maws advertised these pewter spoons in their 1832 catalogue.

p. 18

I have one pewter papboat that I considered a great find. The initials F.H. are stamped on the handle, also the date 1800. On the bottom there is a crown and X and another indecipherable mark enclosed in a circular surround. I subsequently found that this was a mass-produced replica cast from the original mould, not a deliberate fake, used to raise funds for a foundling hospital, (F.H.). Many collectors have been taken in by this. I have since found many genuine ones dated around 1790.

Silver papboats were made by many of the great silver craftsmen and as these are collected by amateurs of silver they may fetch a considerable price. The saying that someone was born with a silver spoon in his mouth comes from the silver papboat often engraved with a family crest. The papboat was also used for supplementary feeding and continued well into the last quarter of the nineteenth century. I have some very beautiful examples by such masters as Hester Bateman, Samuel Massey, John Emes and David Hennell covering the heyday of the silver papboat.

Some feeding bottles, especially made for the purpose, found their way to England from the Continent, upright and with a small vertical spout. These were made of wood or leather.

The next development was the pewter bottle of which I have an example, dated 1750. It has a bulbous body and a narrow neck with a screw top. It could easily be taken for a pepper or salt pot, though there is only one hole at the top and I have seen them on sale as such, alas, before I started collecting. The nipple-shaped end easily distinguishes its use. There are also glass flasks, beautifully engraved, with pewter tops popular in Germany. In shape not unlike the modern upright feeder. This is the earliest type of bottle that the average collector can with great good luck hope to find.

The next great breakthrough came with the elegant "bubby pot"; felicitous name. This was invented by a Dr. Hugh Smith in 1777, devised for his own family. Hugh Smith was the Benjamin Spock of the late eighteenth century whose *Letters to Married Women on Nursing and the Management of Children*, published in 1772, went into many editions in many countries. His *Family Physician* was equally popular. He was well ahead of his time though he had his quirks; for instance "none but a fool first thought of a cradle". The inventor of the "bubby pot" was incidentally a fervent and eloquent advocate of breast feeding.

* Gibson's medicine spoons.

34

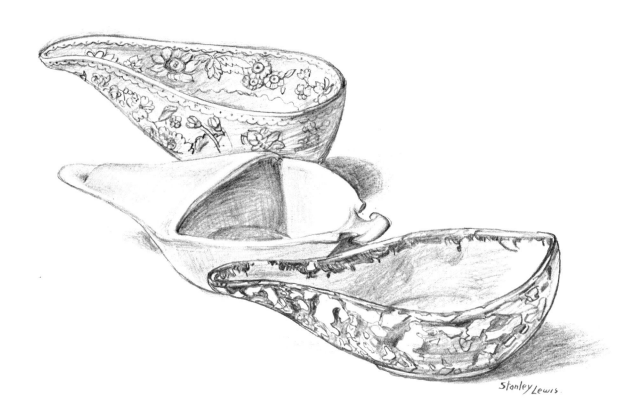

Stanley Lewis

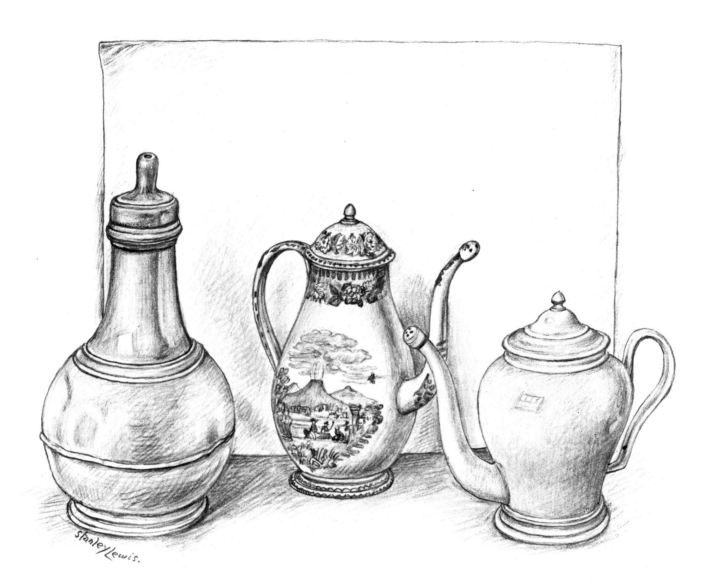

He describes his invention as follows:

I have contrived a milk pot for my own nursery. It appears to my family and to many of my patients preferable to those now in use and may probably be still further improved. This pot is somewhat in form like an urn; it contains a little more than a quarter of a pint; its handle and neck or spout are not unlike those of a coffee pot, except that the neck of this arises from the very bottom of the pot, and is very small; in short, it is upon the same principle as those gravy pots which separate the gravy from the oily fat. The end of the spout is a little raised, and forms a roundish knob, somewhat in appearance like a small heart, this is perforated by three or four small holes, a piece of fine rag is tied loosely over it, which serves the child to play with instead of the nipple, and through which, by the infant's sucking, the milk is constantly strained.

The inventor goes on to say that these pots are also made in the Queen's ware* so that the poor can afford them. The original Queensware was made by Wedgwood. The bubby pot with its long spout and handle is a delicate object and not too many have survived. It is not often found complete with its lid. I have two fine examples, one cream coloured probably made by Wedgwood, the other impressed Wedgwood, with a blue printed transfer of a volcano, presumably Vesuvius in full eruption. A strange subject for such an article, suggestive of much wind! These bubby pots are comparatively expensive, from £50 to £100, but they form the crown of a collection and are objects of great elegance. The coloured bubby pot was originally priced at 7d.

The Spode-Copeland shape book, dated 1820, has a "rose spout tea-taster" made in "usual or small toy size" that is almost indistinguishable from the bubby pot and could easily be confused with one save that the end of the spout is circular like a watering pot rose and not heart shaped. Spode also made toy watering cans in blue and white.

There is a popular adaptation of the bubby pot peculiar to Pennsylvania, known as *mammele* or *mammale*, "little breast" or "little mother". This is basically a tin can of fairly crude construction with a spout extending from the side of the can opposite the handle, ending in a rounded knob with a small perforation. Inside the can a vertical cylindrical tin tube is soldered to the side of the can and the upper end is attached to the inner side of the spout, making a closed channel from the bottom of the can to the spout.

These cans seem to have been introduced to Pennsylvania by the German settlers, who came from Southern Germany in the eighteenth century. There is no record of such cans in Germany and the settlers may have passed through England and adapted Dr. Smith's bubby pot. There is evidence of one being used as late as 1868.†

The beginning of the feeding bottle, recognisable as such, came at the end of the eighteenth or beginning of the nineteenth century. It is made of earthenware, boat-shaped and fits easily into the hand, there is a circular hole in the middle for filling it and often

*In 1765 Josiah Wedgwood finished a dinner service for Queen Charlotte. The product in which it was made was called "cream colour" alias Queensware. It was light in weight and became so popular that it could be cheaply produced.

†This information comes from an interesting article, "The Nursing Can", by Howard Dittrick in the *Bulletin of the History of Medicine*, U.S.A. 1939.

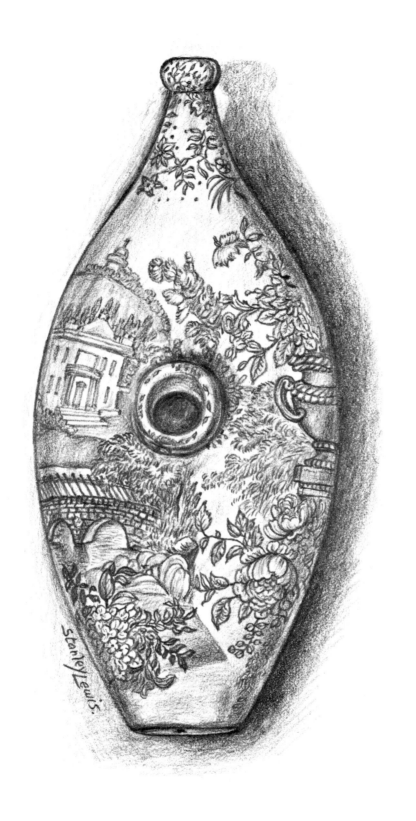

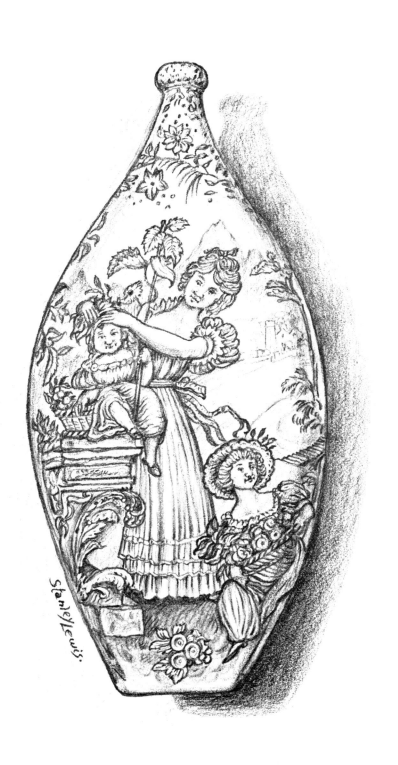

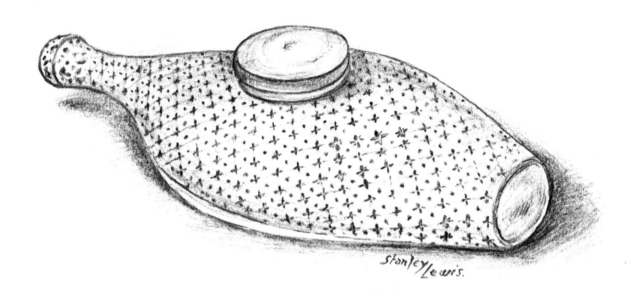

a box wood disc to fit into this hole with a type of valve to regulate the flow of air. These discs are not often found. I have two. The holes differ greatly in diameter, the very small ones obviously made to be blocked by the thumb. The narrow end is sometimes rounded and nipple-shaped, sometimes just a spout to which a teat might be attached. The opposite end is either flat or rounded. Some of these feeders are flat, others bulbous, some are gondola shaped. The early ones are cream coloured and undecorated though they may have ribbing. These are not easy to find in spite of the fact that they are not particularly attractive, or for that very reason. The blue transfer printed ones, made by various potters all over the country and always called Staffordshire blue, though rarely marked, are a delight. They have pastoral scenes, romantic views of ruined castles, the familiar willow pattern and its many variations, floral designs or coloured spots and stars. They could not be more decorative which doubtless accounts for their removal from nursery to china cabinet and consequently the survival of so many. One which I covet but have never yet seen on sale is of brown stoneware with a bust of the young Queen Victoria, therefore around 1840 in date. It may yet turn up. Wedgwood have no record of any feeding bottle manufactured by them, though I have one in my collection. It is gondola shaped. Spode began making them as early as 1810 and continued well into the Victorian period. They were mass produced, inexpensive and sold mainly in china shops for about 2d.

Accurate information on the earthenware feeder is impossible to obtain. Forty-seven letters to various pottery manufacturers were unproductive, only Wedgwood and Copeland-Spode had any records. Doultons believe that they did manufacture them, though they have no record, and that they were distributed by Maws.

There were at the turn of the century some 500 "back street potters" whose work is unnamed and who soon went out of business. When transfer printing became popular print shops, quite detached from potteries, were set up and any potter could buy the prints so that the designs, apart from special ones made by famous firms, can give one no guidance.

Later in the mid-nineteenth century glass begins to replace porcelain. It is sturdier and easier to clean, although the notion of a sterile bottle still lay in the future. These early glass bottles, handmade and boat-shaped, like the porcelain ones that they replaced, are often exceedingly graceful, the glass may be patterned or plain, the neck long and thin or bulbous. Some have panel fluting, others have a design made by pouring the molten glass onto wire netting. It is not always easy to date them accurately. Hand-made feeding bottles with boxwood stoppers were still advertised in Maw's catalogue of 1913, "Old fashioned" being words of praise instead of the ubiquitous *new* of today's advertisements.

In collecting the earlier hand blown glass bottles, one enters into competition with the collectors of glass. Two different glass utensils sometimes seen in antique shops may be mistaken for feeders. One is a painting horn, a recumbent bottle with a long spout to which a pen was tied and a hole at the back. This was filled with paint and the pressure of the finger regulated the flow. I have seen a modern boat-shaped feeding bottle in a scene painting studio, used for this purpose. The other object is a glass bottle for putting in a bird cage. This also is much collected. There is one in the Ashmolean described as a baby bottle.

It is with these, the last of the decorative feeding bottles, that the collector may

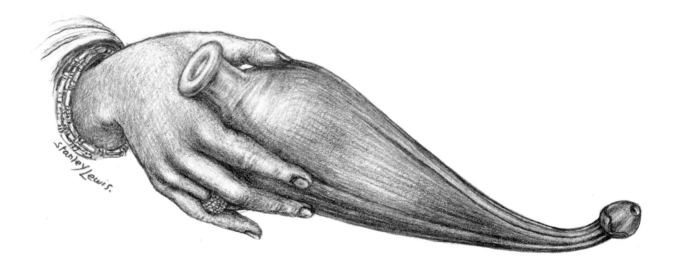

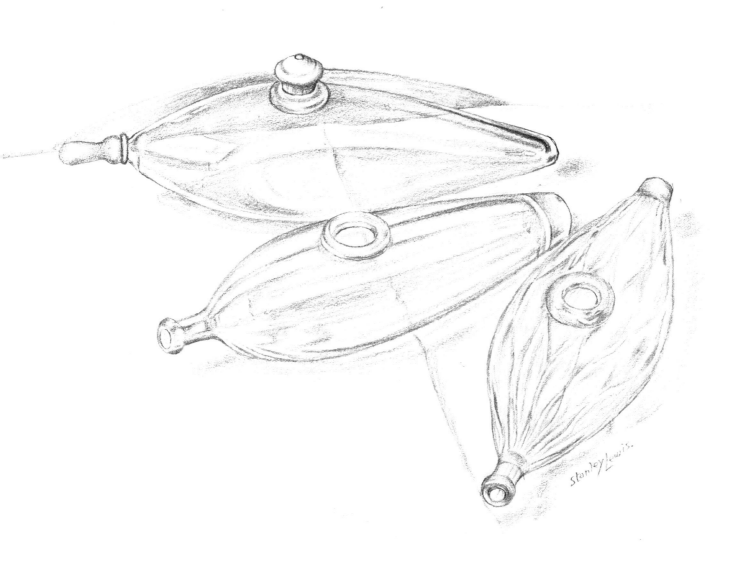

Stanley Lewis.

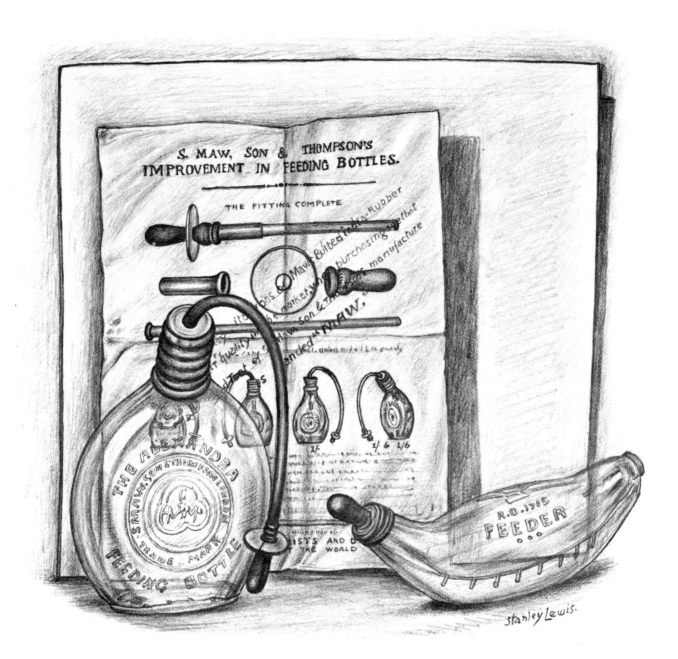

call a halt, his cabinet full and attractively set out. He may, however, as this one has done, for the expenditure of a few more pounds, continue his collection well into the present century for the sociological interest alone and not forgetting that today's object in general usage soon becomes tomorrow's antiquity. I have had bottles offered me—at a high price—as being "very old", because, "it was used by my daughter and she is over forty"!

However ingenious the shape of the vessel the greatest difficulty had always been in finding an adequate teat. Everything had been tried from silver, pewter, leather, ivory and wood to a pickled cow's teat. The India rubber teat first came into use in the 1840's and was patented by Elijah Pratt in America in 1845. Maws in England also developed it about this time.* This epoch-making invention though not perfected until this century finally saw the beginning of the end of the professional wetnurse and may, in the long run, have saved as many lives as penicillin, since the nurse's own child was usually sacrificed to the notorious baby farmers, or to the use of a "sucking bag", any old rag filled with pap.

The first proprietary food was introduced in 1840 and forty years later there were no fewer than twenty-seven on the market which greatly encouraged the habit of bottle feeding.

A French bottle, a *biberon*, with spiral tubes and ivory pins to regulate the flow became popular in 1851, during the Great Exhibition that saw the birth of so many utilitarian innovations. The teat was attached directly to the neck of the bottle. *The Lancet* in an editorial hailed it, writing that, "They had never seen anything more beautiful". This was soon followed by a pear shaped bottle fitted with an imitation rubber breast. It was called a *mamma* and "might be worn by the female in the position of the breast, keeping the food warm all night and day". These inventions soon passed out of sight. I have only seen them in illustration. They were far more suitable than the model that followed.

In 1864, the very year in which Pasteur was able to declare with certainty that invisible organisms always present in the atmosphere caused food to decay, there came a monstrous invention, a flask with a long rubber tube between the neck and the teat. This tube has been described as a "bacterial paradise". As Pasteur's ideas spread this bottle was outlawed in several states in America as a death-dealing device and writers on child welfare called it the "murder bottle"†. In spite of this it was illustrated in a Mellin's food advertisement of 1880 where the baby is held by a smart nanny and also p. 28 in the Sears, Roebuck Catalogue of 1897. It was still on sale and advertised in England as late as 1914; it is mentioned in the *Larousse* of that year. The present writer saw it in use.

I have some examples of these in their original boxes with full printed directions. Included is a long wire brush for the tube. The rubber, of course, has become hardened. There was one particularly popular make named in doubtful compliment after Queen Alexandra, with a picture of the young Queen on the box, which dates it around 1883.

*The rubber teat only became a practical proposition when Goodyear's process of vulcanisation could be exploited after 1839. These early teats had a comparatively short life before losing their pliability. The modern teat was developed by Maws in this country in 1930.

†A truly lethal baby bottle was one found on an Iberia aircraft in May 1970 filled with an explosive fluid.

This actual model was still on sale in 1913. I have also an American example, equally lethal but very pleasantly decorated with coloured transfers of flowers. One later variety of the tube feeder, patented by a Captain Webber in 1887 and still made in 1890, (The Thermo-Safeguard Feeding bottle, Burroughs Wellcome & Co.) had a thermometer fitted into the glass. I have never found an example of this. Though I have a thermometer used for the purpose.

The firm of Maw, founded in 1807, started making feeding bottles in 1832, described in the catalogue of that year as "feeding or milk bottles" 21/- per dozen.* In 1851 they were advertised as being with ivory or India rubber teats. The sale in those days was small, about 1 gross compared to 1,000 gross by the end of the century.

In 1896, (new invention report in *The Lancet* 1.1569, 1896) by which time bottle feeding was gaining ground though still frowned on by some authorities, one of whom wrote that the bottle was "one of the most injurious and pernicious introductions of modern times", there was a new patent that persisted for over forty years. This was the old boat-shaped bottle but with a hole at each end, fitted with a teat and a valve. This made it easy to clean and solved the problem of the regular flow of milk. It was called the Allenbury Feeder and the glass is embossed with a plough design under which is a date, A.D. 1715. It is the first that I have with marks indicating the quantity; 8 fluid ounces. I have one but the original model, apart from the many that followed, is comparatively difficult to find.

It is interesting to notice, when one is looking for evidence of dates in pictures, p. 21 that the artist is usually lagging behind the times. *Punch* has pictures of the tube feeder long after its heyday and the brilliant social commentator, Giles, still depicts the boat-shaped bottle long after it is no longer on sale in the chemist's shops. Doll's bottles, of which I have a number, also tended to lag behind the times.

There are still some interesting models of this century, probably post World War I, upright bottles, made in America, where the glass is embossed with a baby, a doll or a dog; real pop art. I recently found a miniature feeder or comforter, made in Germany p. 115 around 1900; it had remained intact in the family. It is an earthenware model of a small boy, holding up his nappy, the teat fixed to his head. It must have been a daring parent, surely no nanny would handle it, to make use of so shocking an object when the old Queen was still alive.

Today, when bottles are mass produced in many materials and shapes and when the disposable bottle is rapidly coming into fashion, the collector's quest has come to an end, or so it would seem, though I am told there is even a market for early plastics.

I have put one contemporary bottle, the Maw's streamlined *Simpla,* 1969, made of Pyrex glass, in my collection, not only for the reason that it is in itself a beautifully designed object that takes us right back to the elegant German flask of the eighteenth century. We are so familiar with every day utensils that we no longer look at them. Seen as museum objects, in context as one of a continuous line, we look at them in a different light and they in their turn add a new dimension to what has gone before. For this reason I would like to see at least one contemporary object in every type of collection. It would greatly add to our sense of balance and design and give us a new awareness,

*For dating early Maw bottles here are the changes of name: J. & S. Maw, 1828-1860; S. Maw & Son, 1860-1870; Maw Son & Thompson, 1870-1890.

46

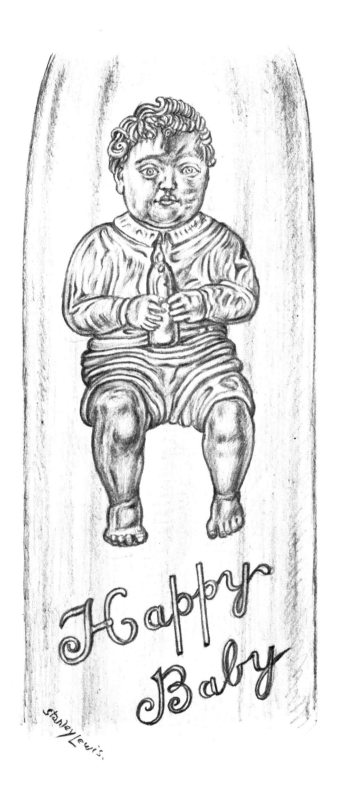

Happy Baby

Stanley Lewis.

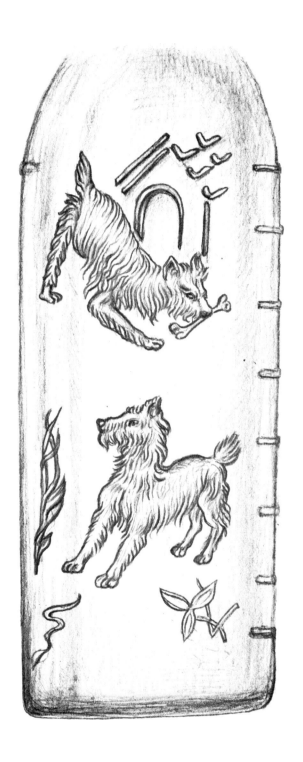

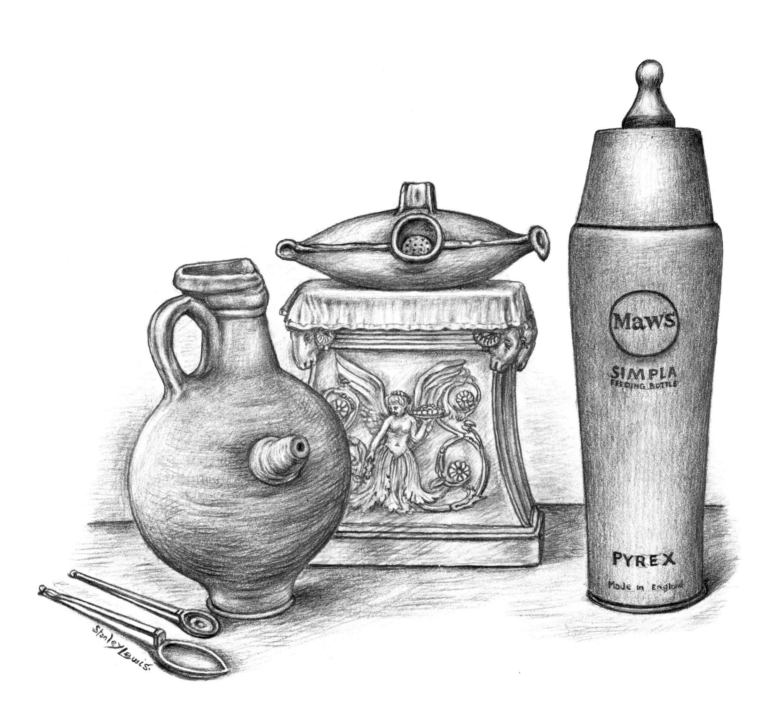

Stanley Lewis.

adding to experience. The pop artist has been working on these lines and has greatly added to our awareness of form, if not always to art.

An expensive addendum to this collection is the food warmer, often a beautiful object in Leeds or Wedgwood. I have one late Victorian model in tin and earthenware with its original box of night lights. On one side there is a picture of the new teat and valve bottle being filled, on the other, the night light and its holder are described as "the burglar's horror", while on the lid there are vignettes of a night-capped man reading in bed, "with it" and on the other, the same man falling downstairs, "without it". p. 113

Silver nipple shields of the mid-eighteenth and early nineteenth century also belong in this collection. They are comparatively rare and costly. I have one by Anne Robertson, Newcastle, 1802. I have also found a silver feeding bottle, boat-shaped like the pottery ones, with a square hinged aperture. It is colonial made, I have yet to identify the mark, probably made in the 1830's for a wealthy *memsahib*. It is the only one I have ever seen, though there is one listed in the Drake Collection in Toronto. Can there be a gold one?

Our subject has covered 4,000 years of infant feeding, and a complete revolution in child welfare. Today the bottle, for good or for bad, is no longer the exception. Its manufacture is a very big and growing business with new patents coming into the market almost yearly. Will they too become collector's items?

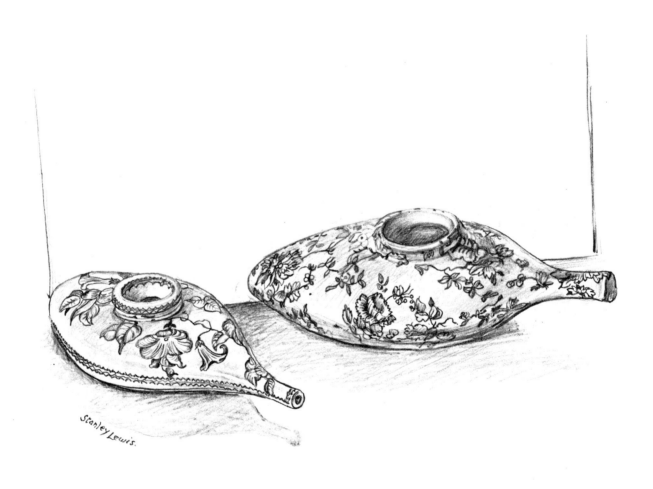

Stanley Lewis.

Bibliography

An invaluable book for the collector of ceramic feeders is J. K. Crellin's *Medical Ceramics in the Wellcome Institute* (1969). Twenty-one splendidly illustrated pages are devoted to papboats and feeding bottles. The catalogue, *The Age of Innocence, The Child and his World*, Holburne Institute 1969/70 has a section on feeding bottles and papboats. There is much valuable information in G. F. Still's *History of Paediatrics* and informative illustrated articles in the *Chemist and Druggist*: T. G. H. Drake, "Infant Feeding and Feeders in Bygone Days", 30th June, 1956 and N. W. Hutchings, "4,000 Years of Infant Feeding," June 28th 1958. Also *Glass Metal Pottery Wood* by Dr. C. H. Spicer, 1962. *A Philosophy of Infant Feeding* by Simon S. Levin is full of information delightfully presented. A recent volume *Antiques of the Pharmacy* by Leslie G. Matthews, 1971, has some good photographs and text. I am indebted to these for much of my information and especially to a fellow collector, Dr. M. E. Alberts of Des Moines, U.S.A., for sending me so many American sources of information where the subject has been studied in depth, and to Mrs. Johnson, a most knowledgeable and generous collector of medical antiquities, to Messrs. Maws, to Mrs. F. Street and the many pottery museums she has consulted on my behalf and to the Pharmaceutical Society of Great Britain.

I am indebted to these for much of my information and especially to a fellow collector, Dr. M. E. Alberts of Des Moines, U.S.A., for sending me so many American sources of information where the subject has been studied in depth, and to Mrs. Johnson, a most knowledgeable and generous collector of medical antiquities, to Messrs. Maws, to Mrs. F. Street and the many pottery museums she has consulted on my behalf and to the Pharmaceutical Society of Great Britain.

The most important collection in England is that of the Wellcome Institute to whom I am indebted. Examples are to be seen in the British Museum, the Guildhall Museum and the Essex Museum in Colchester. There are other important collectors who wish to remain anonymous. In the U.S.A. the Mead Johnson collection in Evansville is outstanding, in Canada, the Drake Collection, Toronto.

III

RATTLES AND TEETHING STICKS

by

ARNOLD HASKELL

Behold the child, by Nature's kindly law,
Pleased with a rattle, tickled with a straw;
Some livelier plaything gives his youth delight,
A little louder, but as empty quite;
Scarfs, garters, gold, amuse his riper stage,
And beads and prayer-books are the toys of age.
Pleased with this bauble still, as that before, ·
Till tired he sleeps, and life's "poor play is o'er".

Alexander Pope. *Essay on Man*

With what a look of proud command
Thou shakest in thy little hand
The coral rattle with its silver bells
Making a merry tune!

Longfellow. "To a child".

There is nothing, Sir, too little for so little a creature as man. It is by studying little things that we attain the great art of having as little misery and as much happiness as possible.

Samuel Johnson

For Tweedledum said Tweedledee
Had spoiled his nice new Rattle.

Lewis Carroll

Art thou not breeding teeth?
I'll get a coral for thee.

Beaumont and Fletcher

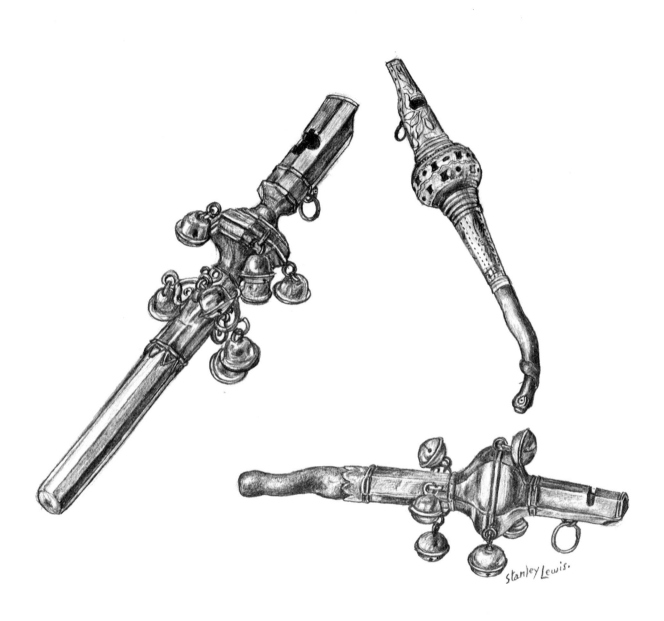

Stanley Lewis.

The rattle is baby's first toy. It is a natural toy; a dried gourd with seeds in it is a rattle from the moment that it is picked up and shaken. It can be made in no time and at no cost, a pebble in a tin or, before tin was known, a dried pea in a terracotta pot. Baby rattles have been known from prehistory and whether in wood, ivory, precious metals, wicker, celluloid, tin, or plastics will continue to the end of time, puzzling and charming the animal or human young. It can soothe or alarm, be rhythmic or sound at random, a truly wonderful thing. There are degrees of sophistication even in rattles and this collector is mainly concerned with the more complex rattle, an object of great beauty made by a master-craftsman and given to flatter the parent as much as to amuse the infant. Rattles of surprisingly modern design have been found at Pompei, and Roman rattles of terracotta, shaped like a bird or a piglet, would delight the child of today.

I have called the rattle a toy though that interesting and informative writer on silver, Eric Delieb, writes that it is not strictly a toy "within the meaning of the term" and it is with one exception not included in any book on toys. But if a toy, as defined in the Oxford Dictionary, is "A plaything, especially for a child; knick-knack, thing meant for amusement rather than for serious use", the rattle would seem to be the perfect toy, however luxurious and ornate. In her book on toys, Antonia Fraser includes the rattle. Such rattles were always expensive, especially when made by a famous silversmith. It is for this reason that Jean Jacques Rousseau attacked them with such violence and suggested that toys in general should be based on natural objects. Today rattles are still expensive though they are much less expensive than most other examples of the silversmith's art, nor are they easy to find. Given as christening presents, they were often handed down in families as heirlooms. The fact that when found they are usually in excellent condition suggests that they were never hurled out of a cradle in play or petulance but were used to amuse the baby by the mother or nurse and they often hung from a châtelaine. In many cases they were too heavy for an infant to handle and the lightly attached bells would present many dangers.

I started collecting rattles after acquiring my first silver papboat, as a decorative adjunct to the display cabinet. I soon became an avid collector of this most beautiful branch of infantilia. I now have a Hester Bateman rattle keeping company with her papboat.

I have specialised in English rattles from the Georgian to mid-Victorian periods. These, though they vary considerably in decoration and shape follow a standard form that serves the triple purpose of whistle, rattle and teether. The stem is usually made of red coral, the *corallium rubrum* from the Mediterranean. Coral is mainly carbonate of lime secreted in the tissues of certain polyps. It forms the vast reefs and islands of the Pacific.

This was highly prized from the earliest times as a substance rich in mysterious sacred properties. It is not too far fetched to see the rattle coral, practical as it is in shape for its particular purpose, as a phallic symbol exactly similar to the popular *cornetta* amulet of the South Italians, also made of red coral. The Romans hung corals round their children's necks to save them from harm. It was also supposed to have great medicinal properties in reducing fevers and in soothing sore gums during dentition. It acted

as a teething ring and a comforter.* The baby's coral is mentioned frequently in literature. Addison wrote in *The Spectator,* "I threw away my rattle before I was two months old, and would not make use of my coral until they had taken the bells away from it". Attached to the coral stem is a silver, silvergilt or gold mount on which there are bells in one or two tiers and on top of this there is a whistle. Attached to the metal mount there is a small ring so that the rattle can be tied to a châtelaine or a ribbon. A rattle may cost anything from £25 to £1,000 according to the period, the maker and the metal in which it is made. An amusing Victorian rattle in tin, or celluloid, bought at a fairground for a halfpenny, can be found for as little as 10/-. I have a delightful wooden one with an engraving of the Bank of England on the rounded end. It is marked "Foreign make"; used perhaps by a future gnome of Zurich!

There is also a type of rattle for an older child that is partly a doll, known as a *poupard* or *marotte,* a doll's head and body on an ivory stick with its whistle. In the body there is a small musical box and when the stick is twirled it plays a simple melody.

There is no end to the books on silver and silver itself is collected as never before, in part as an investment. It is a highly complex subject. The collector of rattles will find little direct guidance from these books, not even one chapter on the subject. They are useful nevertheless for the general knowledge on the subjects of style, hallmarks, maker's marks and so on. I have found that the best bargains come from dealers with a reputation and I have never yet seen a worthwhile piece in a junkshop. The fact that it is silver often makes the small dealer overprice it. It is important not to ask a number of dealers to look out for and report on rattles, or for that matter for any scarce article. This inevitably pushes the price up as the object passes from hand to hand. I learnt this the hard way.

An important thing to realise from the very beginning—of course, I did not do so myself—is not to try and collect a quantity, even of works of quality. Many rattles of the same period are very similar in style. The general pattern has scarcely altered throughout the ages. Try to find original pieces so that the collection is a varied one. Always try to date a piece by its style before looking at the mark, this ability will come very rapidly. It is only by handling an object and by trying to place it in its decorative context that one can judge it.

p. 18 *It would be an omission in any book on the archaeology of the nursery not to make a brief mention of the ubiquitous comforter or dummy (American, pacifier), the to some unattractive but undoubtedly useful article that has fulfilled one of the functions of the coral, far removed from magic or aesthetics. An early rustic form of soother was a piece of pork on a string attached to the infant's toe. There was also the 'sugar tit', a piece of rag with sugar in it, often laced with rum. The object we know today is an obvious by-product of the rubber teat. The word dummy was first used in 1845. In 1901 one large firm alone was producing sixty different types sold at from 1d to 1/-. Frowned on for a long period, though doubtless used behind the scenes in the majority of homes, it has now gained respectability and a blessing from Spock. Its usage is largely dictated by class as the Newsons show in their valuable, *Infant Care in an Urban Community.* In Spain it is ubiquitous, attached to the chain that holds the holy medal or cross, in Italy the sex of an infant is immediately revealed by the colour of the comforter; the traditional blue for a boy, pink for a girl. There are no social distinctions in these countries and less crying babies. However a law was passed, between the wars, by the French Government against the use of dummies *(sucettes).* This, apart from causing much merriment, obviously proved abortive.

56

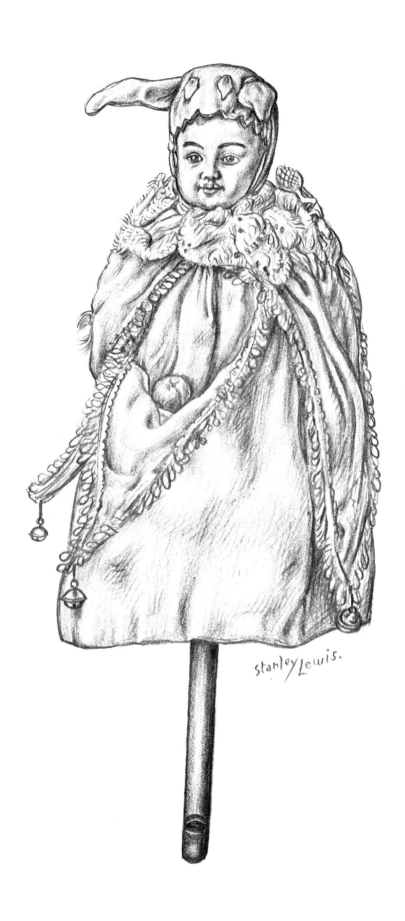

Here are a few points that may prove useful. Rattles of the George I period are often plain, almost severe, beautifully proportioned and hexagonal in shape. Silver gilt, the medium for so many rattles, is silver with a thin layer of gold. Before the nineteenth century, gold and mercury were applied to the silver and then the mercury was removed by heat. Later electro gilding was invented. The earlier silvergilt is altogether softer in appearance, not only through the weathering of time. It is a pale lemon colour, very easily distinguished when two pieces are seen side by side. Bright cut decoration was introduced during the last quarter of the eighteenth century. The instrument used gives it a brilliant appearance as distinct from a scratched design. At about the same period there were produced some delightful rattles, delicately pierced with a chisel or hacksaw, with the bell inside the pierced stem. The rococo style originating from France, where it was known as *rocaille,* was in fashion from 1730–1760, it is ornate, has a sense of movement through its assymetry and is embossed with flowers, birds and garlands. It was later revived in the 1820's in an exaggerated form. Do not be dazzled by the date or the name of the maker, the very best craftsmen had lapses. The mark of a silversmith in vogue, such as Hester Bateman, will add many pounds to the price since one is in direct competition with silver collectors in general. Examine the condition with care for later additions that are out of keeping. The bells are particularly delicate and have often been replaced. This does not always damage a piece but it should be known. The marks are frequently rubbed and undecipherable. Some pieces are unmarked, this may affect the price but it does not spoil the beauty; one is collecting objects and not marks. I do not believe that rattles are deliberately forged, they are, however, often made up from two damaged pieces and it requires little experience to discover this. Some mid-Victorian rattles copy an earlier style but never with any real success. For instance, the rococo of the late Regency period is carried through into Victorian times. It tends to be exaggerated and heavy-handed though at times it has a charm of its own. The embossing is less deep and is not clearly defined, as it has not been worked on from the front *(repoussé).*

The initials sometimes found on the lip of the whistle are often those of the fortunate baby. Sometimes the style of lettering shows them to be of a later date than the rattle itself. Some rattles have been regilded but this does not necessarily rule them out as collector's pieces, though it does affect their value. The coral should be in near perfect condition, it is very difficult and costly to replace and never really satisfactory, since the shape of the coral is an integral part of the design as a whole and the balance is all important. Every rattle has a distinct personality. It is in a sense a piece of abstract art and when its bells are in motion, a mobile *avant l'heure.*

As we advance deep into the Victorian era, the silver rattle declines, there are mass-produced moulded articles of sentimental bunnies or elves attached to a bone, mother of pearl or ivory teething ring, doubtless equally pleasing to the baby but of no aesthetic value. There is an exact parallel between the renaissance lead *putti* and the plastic gnome sitting on a toadstool. The latest piece I found that had character was dated 1922 but that was quite exceptional. The most satisfying modern rattles through following an ancient tradition are those made of wicker. I have yet to see a plastic one that could be described as anything else than "cute and hygienic". The sound of the tinkling bells has been banished from the nursery; more's the pity.

The rattle itself has a teething stick of coral or ivory, perhaps that is why it is not

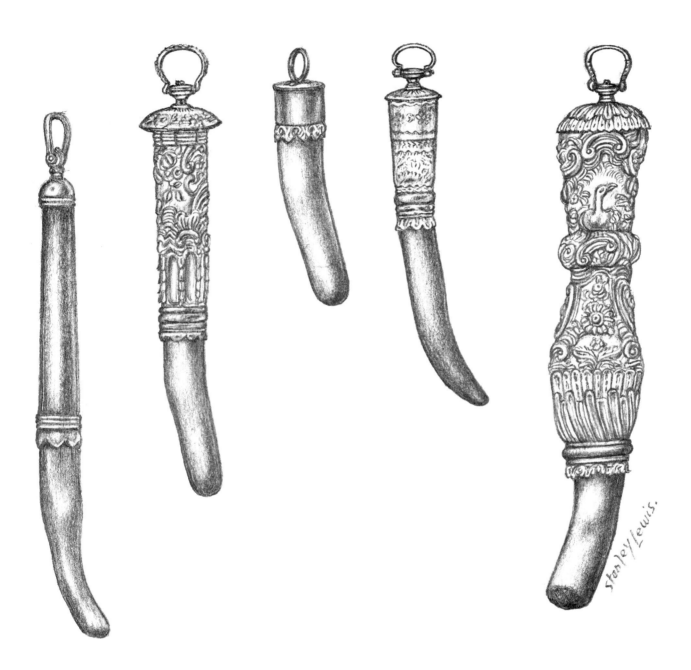

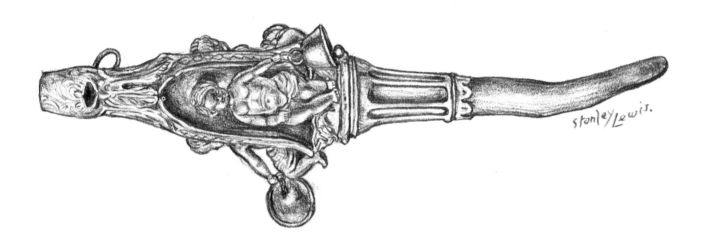

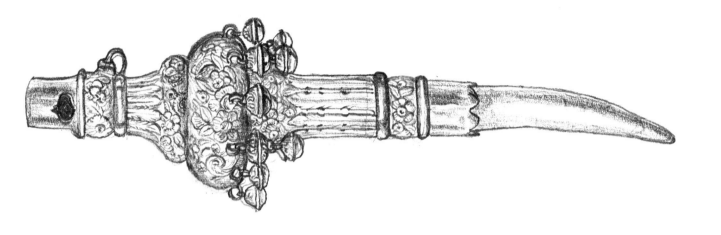

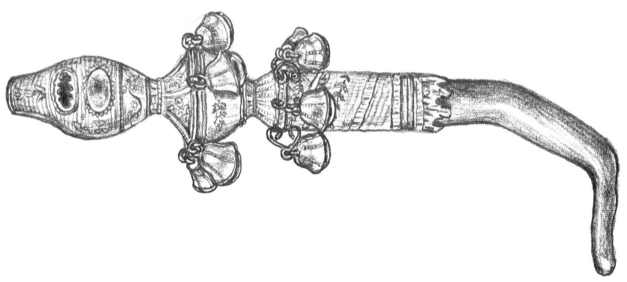

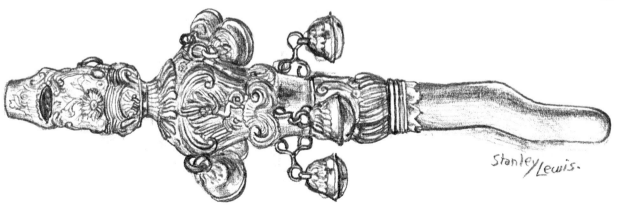

Stanley Lewis.

called a toy, but included in the collection there are teething sticks alone, very beautifully mounted. Delieb writes, "Coral 'gum sticks' were held to cool a babe's aching gums, as well as acting as a 'dummy'." Small toothmarks give the object humanity. One cannot divorce sentiment, even a touch of sentimentality from the collecting of artefacts. Unless it spurs the imagination it is a meaningless activity.

The earliest teether that I have, *c.* 1680, is set in a slender acanthus leaf gold mount. It would form an admirable amulet hung on a watch chain, and as I have said, it is in fact an amulet. Another beautiful silver gilt teether, dated 1740, is more ornate. The setting is longer than the coral with a rococo design embossed with scroll work of roses and other motifs of the period. A third teether, George III, with a silver gilt mount is beautiful in itself but cannot have been very practical for its purpose. The mount might well have suited a walking stick. It is heavy and magnificently embossed with flowers and scrolls, the centre of the design showing a mythical bird with outstretched wings. Far more delicate is a teether, dated 1790, of silver, decorated with bright cutting. Two delightful rattles of the early eighteenth century are plain, even severe, with hexagonal stems. They have enormous dignity. Another rattle by Joseph Taylor, 1812 is of pierced baluster work, bright cut engraving and reeding with the bell in the interior. The coral is carved. The variety of techniques used is endless and the time taken to make each object must have been considerable. These small objects reflect the whole taste of their period in furniture and even in architecture. Such is their evocative quality that from the rattle one may recreate the costume, the nursery and finally the house. A rattle of 1852 with cherubs seated in niches clearly indicates the Gothic revival and gives us a foretaste of the Albert Memorial. Appropriately enough an almost identical rattle by the same makers is illustrated in the *Arts Journal* Catalogue of the Great Exhibition of 1851, p. 238, and described as "a prettily designed infant's coral".

A catalogue of a collection makes dull reading except to the owner, the admirable drawings by Stanley Lewis are far more revealing though, most of all, a rattle needs to be handled. The collection should not be tightly locked in a glass cabinet. The rattle can be as soothing to the tired businessman as the "worry beads" or desk toys that have come into vogue. It can still serve the purpose for which it was intended in spite of a shift in the age range.

I must, however, highlight certain items that have given me tremendous pleasure. One is a silver gilt teething stick and whistle embossed with floral designs supported by three *putti* with outstretched arms. It is dated 1815. Another, the only foreign rattle in the collection, possibly Peruvian about 1820, is of extreme simplicity. It consists of a silver handle with a whistle, surmounted by twisted silver wire from which are hung three bells. A later Victorian rattle by George Unite, a specialist in rattles, 1888, has one large bell with a matt surface engraved with garlands of flowers. It is the only one I have seen with a cat's eye handle, decorative but a long way from the original magic of the phallus-shaped coral.

Not all rattles are made of silver. I have a very beautiful one, Georgian, turned in ivory. A teething ring is attached to what looks like a small billiard ball with a delicately turned handle. It is solid to the touch and beautifully patinated. It may lack the musical tinkle of the bells but one can feel though one cannot see it that the small object that rolls inside the ball is smooth and round and also made of ivory. It rattles with a gentle whispering charm. Because I did not compete with silver collectors I bought it for a

62

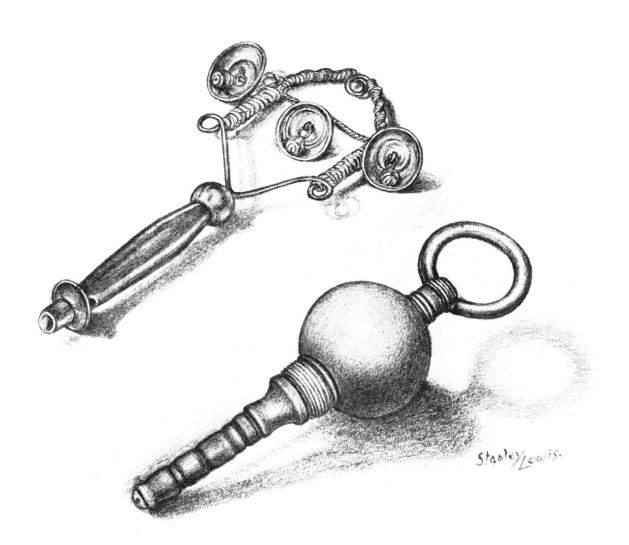

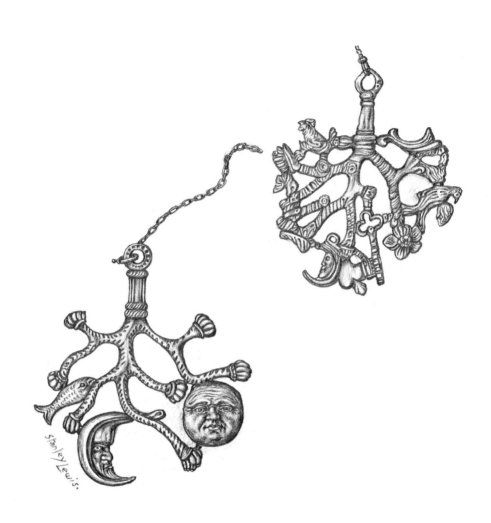

pittance and have never seen one like it. This is essentially a baby's rattle and not a parent-flatterer.

I have another late eighteenth-century rattle with a wooden handle, six metal branches and brass bells with blue beads as clappers. These early popular rattles are rarer than the silver ones, since they were not kept as heirlooms. A later one in celluloid, *art nouveau* period, is also attractive in spite of the fact that it must have been a great fire risk. I have also many charming and ingenious wooden rattles, date and country unknown, made by a craftsman father for his child.

I have added one or two more objects to this collection. Though they do not belong among rattles they come very definitely under the heading *infantilia*. I have never seen any others, though they have been described in a book called *The Evil Eye*, by Frederick Thomas Elworthy, 1895. These are silver charms or amulets "worn upon the breasts of infants in Naples where it is considered their special protection against the dreaded *jettatura* (the evil eye)".

This superstition is still very prevalent in the South of Italy. I remember when I was in Naples very many years ago, an unfortunate Englishman being stabbed because he had openly admired a baby who died later that day of convulsions. One close link with the rattle is that in Naples coral is to this day regarded as a powerful charm. The author describes these *cimaruta* "In all complete specimens two of the attributes are never lacking. These are the crescent and the hand with which the top of every spray is made to finish, except that the hand when alone is bent into the gesture that is a potent amulet in itself, the *mano fica*."

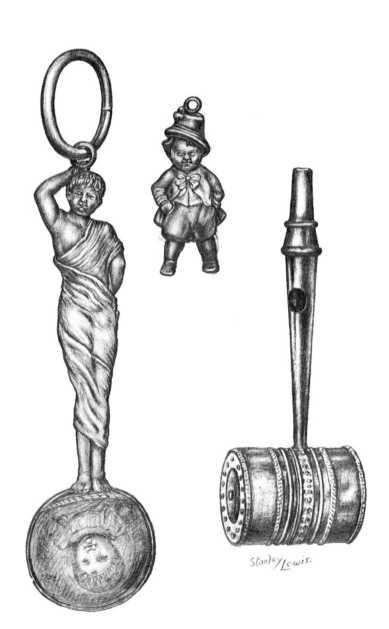

Stanley Lewis.

Bibliography

There is no book dealing with rattles. Eric Delieb's *Investing in Silver* has some illustrations and is most useful in describing period styles. The catalogue, *The Age of Innocence, the Child and his World*, Holburne Institute 1969-70, has a small section on rattles. *Antiques of American Childhood* by Katharine Morrison McClinton, 1970, has an excellent section on rattles and a number of illustrations.

IV

PERAMBULATORS

by

MIN LEWIS

In a go-cart so tiny
My sister I drew;
And I've promised to draw her
The wide world through.

We have not yet started—
I own it with sorrow—
Because our trip's always
Put off till tomorrow.

<div align="right">Kate Greenaway</div>

My best wisdom has consisted in forming a baby-house full of playthings for my second childhood.

<div align="right">Horace Walpole</div>

If I am to write about perambulators, I must write personally and begin at the beginning. Strangely enough I remember it as if it were yesterday.

I was only four when I awoke in the stifling darkness of the night, that night of all nights with Christmas magic in the air!

I reached to the switch above my bed, and the room was light again. At the foot of the bed lay an enormous woollen stocking with the Jaffa orange lying in the toe and a bunch of grapes at the top of the leg; there was a painting book and a Mabel Lucy Attwell Annual, but the greatest joy of all was the doll's pram standing on the flowered hearth rug in front of the Victorian grate.

I was still young enough to believe in Father Christmas, but I was greatly puzzled as to how such a fine pram could have been manoeuvred down the narrow chimney without so much as a scratch or a speck of soot to spoil its shiny newness.

Little Oak, was a comfortless old house, but out of bed I jumped without feeling the icy coldness of the air, and I pushed the little pram to and fro across the bedroom floor.

I heard the mice scratching in the wainscot behind the cupboard door, but I was not afraid because it was Christmas, and I was the proud possessor of my first doll's pram!

My first? Yes, and my last. In a little girl's life there are usually many dolls but only one doll's pram, and this doll's pram, now shining and new-smelling, would carry in its short lifetime many German jointed dolls, as well as the cat, a mongrel dog called Peter and tomboy girls like me!

For many months I was content with my doll's pram, until I saw a little girl pushing a finer model than mine, then how I longed for a fine coach-built pram that seemed to glide with the gracefulness of a swan.

One day, I met the canal-keeper's daughter, a little girl a year older than I who lived in a tiny cottage on the banks of the Monmouthshire canal; she owned no pram, but she was proud to show me a family photograph depicting her holding the handle of a lovely doll's pram. "That was mine," she said proudly, "but our mam gave it away."

Whether the pram had belonged to the photographer in whose studio the photograph was taken or whether she had owned the pram for a little while I shall never know, all I know is, she looked at my doll's pram with gleaming eyes and said, "Can I have a push?"

From that day, she and I became firm friends, and spent long happy hours with the doll's pram until one day one of the front wheels loosened and eventually fell off.

For many years the little pram was discarded and I remember seeing it in the old stable amongst a lot of scrap-iron.

Then came the day when the little pram that I had loved so much was sold to the scrap-dealer for a few pence and was no more.

A sad fate? Yes, and the fate of so many prams, which is why, as I now realise, there are not so many perambulators of the last century and the beginning of this century existing today.

Boys have usually used the wheels for go-carts and the bodies have landed up on scrap heaps. The first conveyance in a person's life has been completely neglected, not a book has been written on the subject, yet it is a part of our life and was an important

status symbol in the late Victorian and Edwardian period, when the nannies pushed their charges in the parks, eyeing one another's prams with curiosity and sometimes with an envy that could trouble the peaceful stroll.

Coaches, traction-engines and trains all have their collectors and enthusiasts, very many books have been written about them and they are understood in their most minute detail, and can be dated to almost within a month. It is a fact that any type of coach or cart, vintage cars and even motorbikes and bicycles have a great fascination for the majority of people, yet the first wheeled coach of a baby is ignored.

Now it is the turn of the graceful and gentle perambulator, the universal carriage of childhood that needs no petrol, no horse, and very little maintenance, only a pair of arms and the ability to steer it through busy shopping streets and supermarkets.

Few of us have ever been driven in an early horse drawn carriage, or chauffeured in an early vintage car, fewer still have ridden a bone-shaker or a penny-farthing bike, yet practically every one of us has been wheeled in a pram, whether it be a primitive box on wheels or a luxury coachbuilt vehicle calculated to make the neighbours green with envy.

Prior to the nineteenth century and indeed almost to the end of the nineteenth century, the vast majority of long clothed babies were carried in shawls, Welsh-fashion, or left at home in a crib or cot, for at that time fresh air was not considered desirable for babies. Very young babies were wrapped in shawls with veils covering their faces so scarcely saw the light of day.

At the twenty-first ordinary meeting of the Royal Society of Arts, on Wednesday 30th May, 1923, a paper was read entitled, "The History of Childrens' and Invalids' Carriages" by Samuel J. Sewell. Although there are some faults in this article regarding dates, praise is due to Mr. Sewell for attempting to write on a subject on which no research at all had been carried out.

In his first paragraph he states:

The physicians of all countries agree that a woman is not fitted by nature to carry a babe in her arms, on her back, nor on her head or shoulders, these are injurious to both. Hence the need of a miniature carriage.

Mr. Sewell was not too happy about the name that was used to describe a baby carriage either, for he stated:

Such vehicles are generally called perambulators or bassinettes. That nomenclature is, I must admit, unsatisfactory since the first name comes from "per" and "ambulare", meaning to walk through or over, and thus it is the person who wheels the vehicle who is the perambulator and not the carriage itself. And as to "bassinette" that is French for a cradle made of wicker, and wood is the material mostly used for the bodies.

However, whether Mr. Sewell liked the description or not, the baby carriage became known as a perambulator, and more commonly abbreviated as a "pram" as it is still called today. In America it is called a baby carriage or buggy.

There is no definite proof that perambulators have been in existence for many

72

centuries but part of a scroll painted by a seventeenth-century Chinese artist shows a child being pulled along in a chair on wheels similar to a perambulator.

It is presumed that the fore-runner of the English perambulator was the hop-wagon used by hop-pickers for conveying their babies and cooking utensils. This wagon was a crudely constructed box fastened to axles of wood fixed to four wooden wheels.

This primitive construction gradually developed into the "stick wagon" which had no upholstery and was drawn by one shaft or handle.

Having to pull and not push made it impossible for the mother to see whether or not her child was safe, and as there were no safety straps at this time, falling out accidents were frequent.

Somehow the coachbuilder at this period could not get away from the idea of horse-traction, and it was sixty years later that a baby carriage was fitted with a handle at the back instead of a pole in front and could then be pushed instead of being pulled.

Even when the first baby carriage was manufactured by an unknown inventor about 1840, it was built not for a small baby to lie in, but for a bigger child, a toddler who was too big and heavy to be carried. It was still an uncomfortable as well as an unsafe carriage made of wood with three wooden wheels and iron tyres.

It was the handle at the back that changed its name, for ever afterwards it became known as a perambulator.

p. 87 This type of three-wheeled upright perambulator continued to be used until about 1880. An improvement on the old stick wagon was an upholstered seat, otherwise it was just as dangerous for a fidgety child as the stick wagon.

The earliest known baby carriage in this country was made for the children of the 3rd Duke of Devonshire in 1730. The body was shaped like a scalloped shell and was complete with a canopy and apron; the undercarriage depicted snakes that linked up with the springs. The snake design was obviously used because the Cavendish snakes form part of the Devonshire family crest. This early baby carriage was designed to be drawn by a small animal, for the collar of the animal that pulled it still exists.

The second baby carriage belongs to the same family, for it was made for Lady Georgiana Cavendish, daughter of the 5th Duke of Devonshire, in 1784.

This particular baby carriage was similar in design to the later carriages, for it was constructed to imitate a C spring and perch-coach. It had four wheels, 18 inches and 12 inches, made of wood, iron shod, wooden axles, a leather canopy, and was upholstered in luxurious fine printed linen. There was one handle or shaft for pulling the carriage. Both these early baby carriages are in perfect preservation and are still to be seen at Chatsworth House.

In 1876, a coachbuilder built a four-wheeled perambulator for his grandchildren, but the police would not allow his daughter to wheel it on the pavement. Having four wheels it was classed as a road vehicle.

This difficulty was overcome however about 1880, when the four-wheeled bassinette, suitable for babies as well as young children, superseded the three-wheeled pram, and the four-wheeled perambulator was no longer classed as a road vehicle but could now be pushed along the pavements without police interference.

The bassinettes which had been made and used in France as cradles, were imported into England and fixed on to wheeled undercarriages here.

These first bassinette prams were completely flat with no well, and therefore were

74

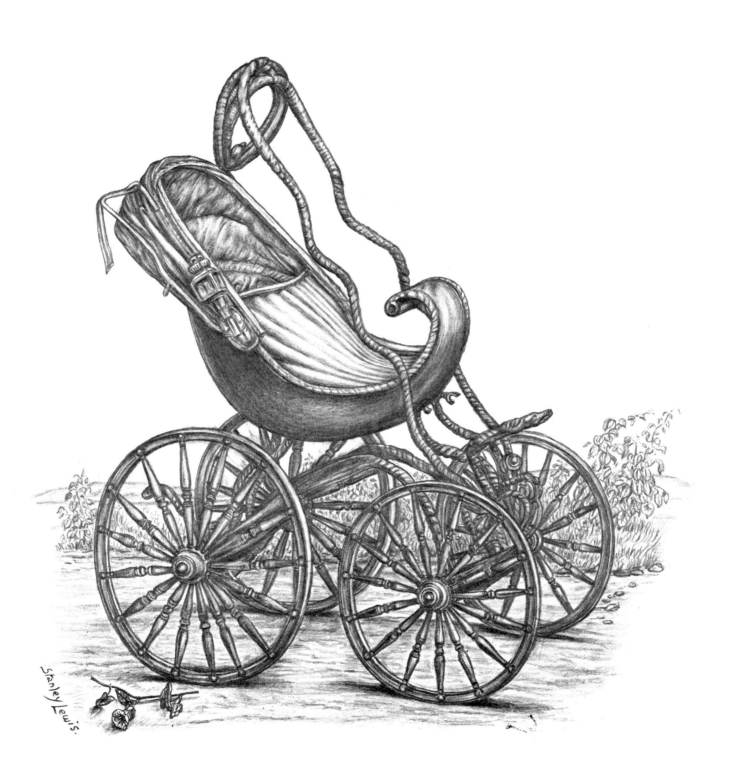

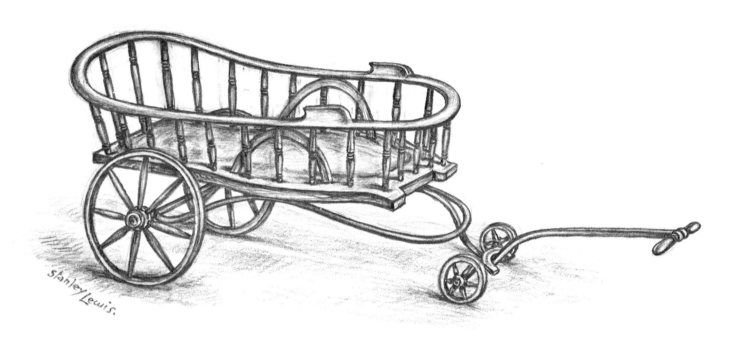

only suitable for infants, then someone decided that a seven to nine-month-old baby would sometimes want to sit up and take notice, and the well was introduced for the first time.

Extract from *The Times*, concerning Prince Charles, 8th December, 1948.

The Royal Pram

The infant Prince has made his first acquaintance with the gardens of Buckingham Palace. He has been "wheeled round in his perambulator". It is taken for granted that he should go out in a perambulator but in fact this vehicle is quite a recent innovation. It was not until 1857 that Charlotte Yonge put the word into circulation when she wrote that "little Constantia Wood arrived, driven up in a perambulator". Babies have a much easier time nowadays than they used to do. From time immemorial their first outings were made, wrapped up in shawls or their equivalent, in the arms or on the backs of their mothers or nurses; and this is still, of course, the only method known to many babies. There is a rather obscure reference by Wyclif to "waynes" being used for the "carriage of little children" but this must have been very heavy going for a fourteenth-century infant who, if he had been able to express an opinion, would probably have much preferred to be carried. The luckier children had an early taste of preferential treatment when baskets were made to carry them on horseback. Roads were not suitable for wheeled vehicles until the eighteenth century and the first English "baby carriage" was probably that built for the Cavendish family about 1730.

The Science Museum at South Kensington has several examples of early perambulators—though it has not the space to exhibit them at the moment—and would be glad to acquire more. One of these, dating from 1820, is properly called a "stick wagon" because it resembles a miniature 4-wheeled hay-cart, with high sides made of sticks several inches apart. The axles and wheels were similar to those of horse vehicles, but there were no springs and the whole contraption was pushed along like a tea-wagon on a modern railway-platform. A perambulator of *c.* 1845 seems a little more comfortable, with its low box-shaped body, leather upholstery and wicker sides; it was pulled from the front by a long wooden shaft. The earliest royal perambulators made their appearance at this time. Pushed from behind, they had three wooden wheels rather like a bath chair, crude springs and perky little sunshades with long tassels. Queen Victoria bought three of these for her children and paid 4gns each for them.

Light wire-spoked wheels and rubber tyres were first used on perambulators in about 1875 and henceforth their development has kept pace with that of other and lordlier vehicles of the road. "Perambulator" in its ancient sense can now be marked "obsolete"; it no longer means who "performs a perambulation for determining boundaries", still less a pedestrian traveller—in the sense in which James Bone used it when he wrote his excellent book, *The London Perambulator*. The perambulator is now nothing more nor less than a pram; but the pram in which the infant Prince is taking his outings is itself a prince among prams, for it had the privilege of conveying his mother some twenty years ago and must surely be preserved for posterity.

77

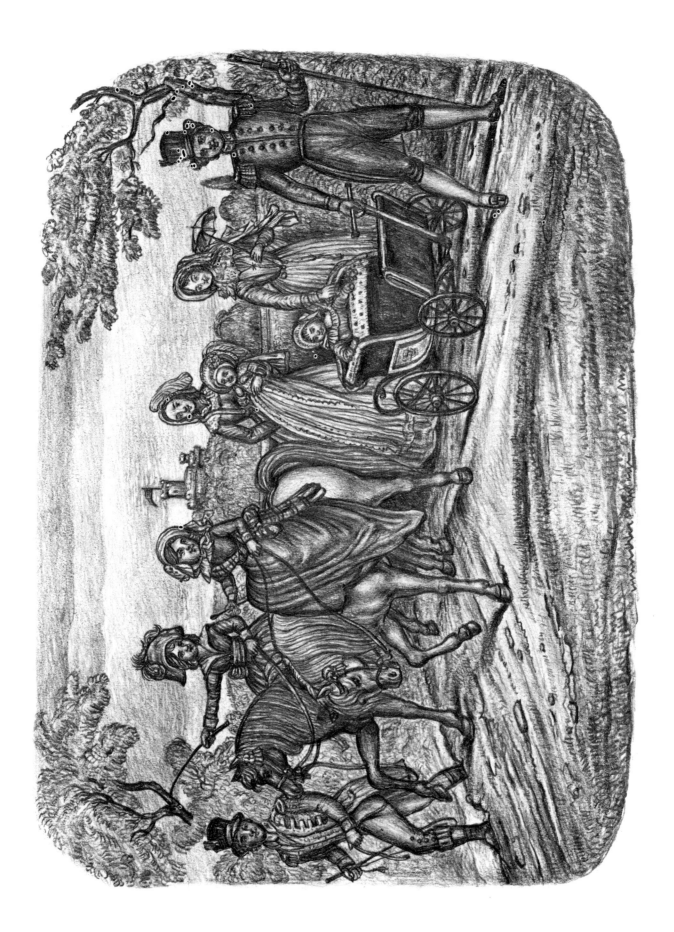

When Queen Victoria came to the throne in 1837, England was a prosperous country, but alas, there was a tremendous contrast in living between the rich and the poor.

The wealthy lived in magnificent houses staffed with servants, and amongst the servants were the children's governess, and the nursemaid and undernurse. In contrast the poor lived in great poverty and squalor and were lucky to survive at all. Young children went a-begging in the streets, most lived in the slum of a crowded, dingy, dark, damp room, while the workhouses and other poor law institutions were badly overcrowded.

At this period, coaches, carriages and perambulators belonged to the rich, for almost as soon as the perambulator industry began in 1840, the perambulator became a status symbol.

It can be presumed that poorer children continued to be pulled around in a box on wheels such as the hop-pickers used.

A printed card which a friend recently sent me showed the Royal children of Queen Victoria wandering through the grounds at Windsor, and included this description:

How gay and colourful was the cavalcade which wended its way through the grounds at Windsor one still summer day, when the air was filled with the high sound of children's laughter, and the bird-like lovely young voice of the little Queen, whose delight was to spend long happy hours walking and riding with her children. Studious gentle Pussy, enchanting in her long green riding habit, sat side-saddle upon her blue-rossetted white pony. A year younger than his sister, Edward, high-spirited and adventuresome, sat astride his pony and was led by a groom. In her baby carriage was tiny Alice, and immediately behind her, and carried upon the arm of his nurse, was Alfred.

The baby carriage used by tiny Princess Alice was a miniature replica of a horse drawn carriage with one shaft in front.

You will probably wonder why I became so interested in perambulators, and the answer is simply that, apart from the precious memory of that Christmas morning, when I saw my first vintage perambulator I thought I had never seen anything more elegant or beautiful.

It was a mild, sunny day and I was browsing around the many antique shops of Bath, that fascinating and beautiful Georgian city, when I accidently came across a small shop tucked away from the prying eyes of the main thoroughfare.

This shop was not an ordinary antique shop with one or two highly polished specimens of antiquity displayed in the window without a price tag. Instead, it was a large window displaying a rumbled, jumbled assortment of bric-à-brac, the type of shop that most people love browsing around.

It was not an easy task attaining admittance to this shop, mainly because the owner lived alone and was wary of strangers, and because like so many dealers she preferred to deal only with people in the antique trade.

However, as I claimed to be "in the trade", she unchained the door and I was admitted.

The disorderly objects that bestrewed the large, draughty, dingy room were too numerous to attract my eye, except one object, and that was a vintage pram.

Having never seen a pram like it before, I could not at that time date it. I made a wild guess of course, and dated it much earlier than it was. Since then I have discovered that it was made about 1890. The body was of wood, painted in a mellowed maroon red, with a line in gold of signwriter's precision. A floral pattern decorated the body. The hood was of leather and lined with cloth, and the joints were of brass. The body was upholstered in buttoned leather, the handle bar was of white porcelain, and the wheels, of which there were two large and two small, had brass hubs and with the undercarriage held the body suspended by leather straps.

My first impression was of surprise. I was surprised that such a gem could have been preserved for so many years without mishap. I exclaimed with delight, "Where did you find it?"

The dealer did not share my enthusiasm; the vintage pram had not had the same affect on her as it had on me, for she looked at me as if I was mad.

"Oh that old thing," she said. "Somebody was cleaning out the attic and found it there."

We settled on the price, and as I had never bought such an article before, I had no idea of the value.

With my first vintage pram safely secured on the roof-rack of my mini, I returned home as happy as an archaeologist after unearthing some treasure that had lain buried for thousands of years. In my case it had been "buried" for less than a hundred years before being brought to light again.

As I sped the miles along I wondered whether the pram would have the same effect on my husband, Stanley. It was a chance I had to take and I could hardly wait to see his reaction.

I was not disappointed, and now I wonder why I had any doubts because we have always admired the same things. Anyway his first words were, "What a gem, where ever did you find it?"

My enthusiasm was rewarded. We unstrapped the pram and gently lifted it down, and I could not have felt happier had I discovered an old master!

The brasswork needed cleaning and the bodywork and leatherwork polishing, but apart from this the pram was in excellent condition.

Like all enthusiasts I wanted to show off my treasure, and what better place than in the front window of the shop. Out came the pieces of furniture, brass and copper, and in their stead the pram took pride of place.

I soon discovered that the pram drew great attention; it became a talking point, and nearly everyone agreed that it was a work of art. Unfortunately I had no intention of selling it, but just to show how other people react, I will tell the story of the day I had closed the shop and was on my way home when I noticed a car pull up alongside the shop window and an elderly gentleman alight. He stood for more than five minutes gazing at the pram and, being curious as to why he was so interested, I retraced my footsteps to the shop-window to join him.

"Would you like to have a look around the shop?" I enquired.

"Not really," he replied. "I was just looking at that beautiful perambulator. How much are you asking for it?"

I now found myself in the embarrassing position of having to say, "It is not for sale," but then I suddenly decided to price it high so that he would have no hesitation in refusing to buy.

I heard myself say, as if in a dream, "One hundred pounds."

The elderly gentleman did not bat an eyelid, but prepared to do business. When I saw him produce a cheque book I was completely shattered, "Oh I couldn't accept a cheque," I said. "Not for such a large sum of money anyway."

"Oh well in that case, perhaps you will reserve the pram for me until I can acquire the necessary cash," he said.

He wrote down his name and address on a scrap of paper, and I asked him out of curiosity why he wanted to buy the pram.

His answer surprised me, "To display in my hall."

I went home feeling very mean and upset, what on earth could I do? I had no intention of parting with the pram.

After a soothing cup of tea, I decided to write the old gentleman a letter stating why I could not let him buy the perambulator. Then, feeling as if I had got a heavy load off my mind, I posted the letter and thought no more about the incident.

I never received a reply from the gentleman, and I have never seen him since, but I only hope that he has forgiven me!

Such is the burden one has to bear in becoming an enthusiast. I soon realised that to become a pram-collector a great deal of house room was required. Small objects such as rattles and feeding-bottles take little space, while a perambulator is as big as an armchair or a small table.

Fortunately the Old Manse is a fairly large house compared to modern standards, but even then I would have to sacrifice many treasured pieces of furniture to make room for my collection; and as a matter of interest, what does one call a collector of prams?

A collector of dolls is, I have recently learnt, called a plangonologist, the name comes from the Greek word "plangon" meaning a small wax image. Can I call a collector of prams a pramologist?

Strangely enough a replica of this first perambulator I had collected is to be seen at Madame Tussaud's, as one of the most famous, or more correctly infamous, prams in history, a model of the year 1890, and described in the press as a "bassinette perambulator"

It survives in the Chamber of Horrors as a memorial to Mrs. Pearcy who, without the sinister detail of its use, would have been remembered, if at all, as just another perpetrator of a sordid murder, though there is one other memorable touch. When the police arrived she was whistling to her own piano accompaniment. They asked her what she had been doing to get her kitchen into such a mess. She chanted, "Killing mice, killing mice, killing mice."

It was in this kitchen that Mrs. Pearcy murdered her lover's wife, putting the body in the perambulator that lay waiting in the hall. With the baby on top, she was seen pushing the heavy load from Priory Road, Kentish Town, to Crossfield Road, Hampstead where she dumped the body, leaving the baby, dead or alive, a little farther on. She abandoned the pram in the respectable neighbourhood of Hamilton Terrace.

SEA-SIDE ATTRACTIONS. Nurse.

What could seem more innocent than a woman panting uphill pushing a pram with a baby in it covered with a shawl?

What more dreadful journey can such an innocent vehicle have known!

My second vintage pram was discovered in the same antique shop, but it was an entirely different type of carriage. Slightly lower in the social scale and used by mothers rather than nannies, this type of perambulator was not called a bassinette but a mail-cart. The mail-cart was supposed to have originated in Leeds in 1886, at the factory of Simpson, Fawcett and Co. Shortly after, it was also made by Wm. Wilson and Sons, of the same city, and later by other firms. According to Mr. Samuel J. Sewell's article in 1923:

> it was introduced as a plaything for boys and girls, but since mothers persisted in using it as a vehicle for infants, many patents were taken out to make it available as both a pram and a car. The sales for some fifteen years were enormous, and then dropped to so small a figure that most pram makers now ignore mail-carts.

This mail-cart that I saw for the first time, had curved shafts and was in excellent condition.

It is interesting to observe that the pram firms when they advertised their goods gave every type of pram a name. In the Army and Navy Stores Catalogue of 1907, there is a page devoted to mail-carts.

There was the *Trojan,* which had a reed body and detachable tray to form a bed.

The *Cruiser* had a reed body, but was convertible into a single, double, or reclining car.

The *Ralli* was a single car with a wood body for child to lie or sit.

The *Valentine:* wood body for two children; one child could lie down and the other sit up.

The *Dover:* cane body; single cart for child to lie or sit up.

The *Coronation* car: strong wooden body, single car, painted brown and upholstered dark green.

Although I did not know it at the time, it was the Coronation car that I had discovered.

It had a strong wooden body painted brown with chip carving on the sides. There were two large wheels and two smaller ones fitted with rubber composition wired-on tyres; two pieces of metal attached to the undercarriage to act as a brake when resting on the ground; the hood was covered with American leather cloth; there were brass barley twist joints; there was also brass barley twist decoration on the body and detachable tray and brass hubs on the wheels; the undercarriage was attached to the body with leather straps, and the padded upholstery was in American leather cloth.

Strangely enough, the lady dealer was asking twice the amount she had asked for the first perambulator, and at the time, as I have already stated, I thought the mail-cart was earlier than the bassinette so paid what she asked and took my second vintage pram home.

The two together were so different in their construction that it was obvious that

one could acquire an interestingly varied collection of vintage prams if one could find them.

In all the years of searching junk and antique shops, the two I had acquired were the only two I had ever seen for sale.

But fate took a hand again for, as I was driving along a country road, I saw on the left-hand-side of the road an attractive farmhouse set back from the main road by a grass verge.

A large sign was fixed to a post, and on it was written, "Bed and Breakfast, Brown eggs for sale", and underneath in smaller letters, "Antiques".

I pulled up near the grass verge, and ventured to walk to the front door, making sure there were no sly dogs waiting to pounce.

After a long wait, the door was opened by a grey-haired lady, and I asked her whether I could view the antiques she had for sale.

"Oh it's my son who does the antiques," she said. "Come in and I'll call him."

I sat in the large, cool parlour until he appeared, a man in his thirties. Jim Wills had been brought up as a farmer, but he loved old china and glass. He led me through a dark hallway into the yard, through a wash house and up some wooden stairs to a small room which he had furnished with all the small objects he had for sale. But there was only one object I wanted to buy, and that was the old perambulator tucked away in the corner next to a penny-farthing bike. This particular pram was unusual because it had two handlebars, one at each end of the body. The suspension of the body by two handles was invented by T. Simpson in 1887 and is known as the double suspension hammock. But alas, Mr. Mills did not want to sell either the penny-farthing or the pram.

"We have had a lot of fun in the local carnivals with this pram," he said. "And we have won several prizes with it too."

I must admit, and I am sure he would not object, that I was horrified at the suggestion that a great hefty man, dressed to look like a baby to entertain the local bystanders, should be installed in such a beautiful vehicle.

I tried to laugh at the imaginary spectacle but I could not. The only thought in my mind was how I could persuade him to sell me the pram.

"I would not want to resell it," I pleaded. "You see I am a pram collector."

I know he had never heard of such a person before, and by the look on his face I do not think he believed me, but I continued to plead and gradually he became more sympathetic.

"What good is this old pram to you?" I asked. "You are not a vintage pram collector."

"No," he replied. "I am not."

"But I am, so please let me buy it."

It was the hardest bargaining I had done so far, but we finally agreed on the price and triumphantly I bore my third vintage pram home.

The three prams together, so beautiful in their different ways, were an unusual sight and nearly everyone who came into the shop remarked on it with interest.

There was a difficulty, however, for nearly everyone who saw them wanted either to know the prices or was keen to purchase one. This thing seemed to be catching. The refusal to part with one caused more annoyance to the customers than was imaginable so, not wishing to cause further annoyance, we waited till the dead of night and then pushed the perambulators up the road from the antique shop to the Old Manse.

Installed in the hallway, they really enhanced the old house, all they now needed were the occupants.

I suppose anyone who collects vintage perambulators must have a more than sneaking regard for dolls, and to my mind dolls were nearly as enchanting as prams.

Like most people I enjoy the occasional visit to London, even though I can rarely buy to sell again, but my visit this particular day was to view some dolls, very large dolls they had to be, for small dolls would look lost in a baby pram.

I succeeded in buying the largest doll I had ever seen, she was in fact so big that no child could have handled her, so I believe she was originally made to model children's clothes in a dress shop.

Like the majority of bisque dolls, her origin was German, and there was something appealing in her large brown eyes. Dressed in Edwardian clothes, she was the perfect size for the mail-cart, and with the doll inside, the mail-cart seemed to come alive.

Having found one perfect occupant for the mail-cart ("Mail-cart!" said a doctor friend. "If that is a mail-cart what is a female cart like?"), I was eager to find two large baby dolls for the bassinettes, and this I soon succeeded in doing.

Meanwhile a dealer who was opening a shop in Marlborough wanted something unusual to display outside his shop, and his wife, having recently had an addition to the family, thought it would be a splendid idea to buy a vintage pram. They thought a baby in an old pram would draw attention to the shop window.

He heard that I had several, for word soon gets around in this trade, and he therefore drove to Beckington hoping that I would sell him one of mine.

Yet again I had to refuse, but he quite understood why and promised that if he ever came across any unusual prams he would immediately let me know, and that was how I bought from him the first three-wheeled pram in my collection. To me it looked very early, but soon I learned that it could not have been earlier than 1840–50.

This vintage perambulator had a wooden body and three wooden wheels with iron tyres and decorated brass hubs. It was re-upholstered in padded black leather, the body work was black with yellow line decoration, and it looked the most precarious perambulator of all.

There were now four prams gracing the hallway, and each one completely different. I remember Stanley saying quite definitely, "You must not buy any more vintage prams, or we shall have no room for anything else."

This of course was a logical point of view, but now I had tasted the joy of being a collector of perambulators, how could I stop? Anyhow who has ever heard of a logical collector?

86

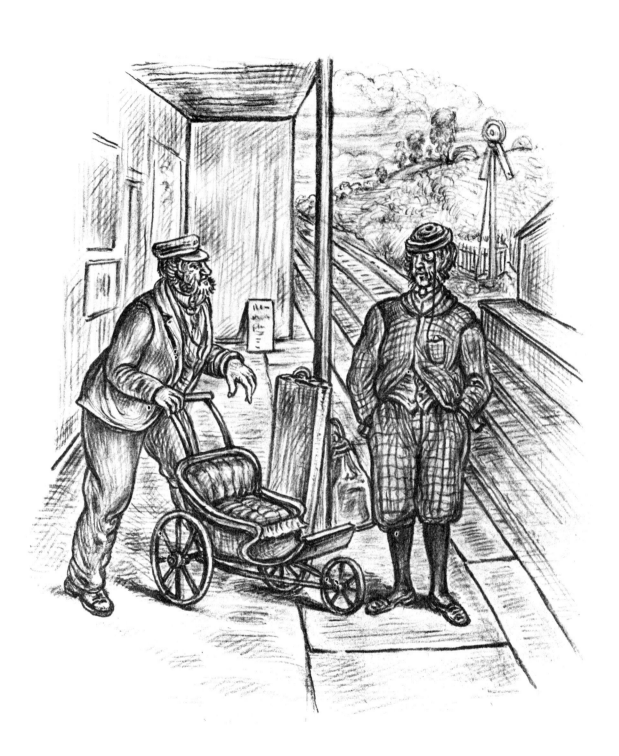

I again read Samuel J. Sewell's paper on perambulators which stated,

In 1840 several men took up the manufacture on a small scale of a three-wheel vehicle, which they called a child's carriage, notably John Allen, of Hackney Road, E., and A. Babin, of New Street, E.C., and they found that the London people were now open to buy prams. Success caused others to enter the trade, particularly Charles Burton, who in 1853 took out the first patent for prams in this or any other country. There never has been a "master patent" the nearest approach to such being the suspension of the body by T. Simpson in 1887 from two handles, and the outside spring chassis of Charles Thompson in the same year.

In 1843, Babin and Ripkey and John Allen were the only makers of "child's carriages".

By 1850, the makers numbered four, owing to William Parker, founder of Parker Bros., of Curtain Road, E.C., joining the ranks, and he is one of the several who lay claim to having first used the word "perambulator".

In 1852, Charles Burton started a small factory in Hampstead, and here constructed a pram according to his, the very first patent, dated 1853, and opened a showroom in Oxford Street, London, in a district which within three years became the centre of the trade.

In 1856, there were four shops devoted to what were now called "perambulators", all within a few hundred yards of Burton's showroom, and no fewer than twenty makers in all London.

Burton appears to have considered his folding device the most important feature in his patent, and the other makers left this alone but copied some of his ideas or improved on them, particularly J. R. Frampton, who, in addition to chairs, made in Trinity Street, S.E., "stick wagons".

p. 76

On seeing the Burton patent pram in 1853, he decided to improve the three-wheeler, and constructed his wheels with metal for the hubs and spokes and gave them half-round iron tyres and iron handles.

His son, Louis Frampton, still alive in 1923, remembers the first of these prams, in which he was placed for a trial trip in South London. A big crowd surrounded the pram, and orders for it at once flowed in, mostly from the working classes, who hitherto had not been purchasers of real prams.

My next purchase was a wooden folding pushchair covered with carpet-bagging cloth, and I recalled the memory of being pushed down the rough drive of Little Oak, in the 1920's in a similar one. It was a rough ride, but an outing I looked forward to every day, except of course when it rained, for there was no hood or apron to keep out the weather.

So far, I had only collected baby prams, but when a gentleman rang me, offering me a doll's pram that had once belonged to the nursery at Longleat, the home of the Marquis of Bath, I could not refuse such an offer. The pram had a Lincrusta Walton body with reed decoration forming a delightful pattern. The padded American leather-cloth upholstery was in a delicate pink, the handlebar was white porcelain, and there

88

were brass joints on the hood. Unfortunately, someone had painted the undercarriage in a thick white paint, and it took me a week to scrape it off.

The first doll's pram ever made was manufactured at Frampton's factory in Trinity Street, S.E., in 1862. It was made by the workers as a gift to their employer's daughter, the first and only one made there since Mr. Frampton thought that no trade was to be done in such "nonsense", as he called it.

How wrong he was, since the production of toy prams was soon taken over by others, and the output became and still is enormous.

While talking to a friend at Bath, I learned that Arnold Haskell was organising an exhibition of the child's world, "The Age of Innocence", at the Holburne Museum, Bath. My friend had offered to loan some of her fine collection of dolls, and without really taking it seriously, I casually remarked, "Maybe Mr. Haskell would like to borrow some of my vintage prams".

She said she would mention this to him when she saw him, and at our next meeting she was able to tell me that he was delighted with my offer and readily accepted it.

As yet, I had not met Arnold Haskell, although I knew of his world-renowned association with ballet. When we did eventually meet, I realised that he had a fantastic personality, and showed as much enthusiasm for my pram collection as I felt. I even parted with one to him, which immediately became a treasured possession and a feature of his front hall.

Thinking back now, I feel that meeting him was the highlight of our life in Somerset. Almost his first words were, "You must start a perambulator museum, I don't think there is one in the country."

I must admit that the idea had crossed my mind once or twice, but it needed his spark of enthusiasm to get things organised.

From that day onwards, Arnold became a frequent visitor to our home, every vintage pram I bought became as much a joy to him as it did to us; he desperately wanted to know the history of each pram, but as there were no books yet written on the subject, how were we to find anything out about them? Perhaps the greatest difficulty at that time was dating each pram, for to us they looked older than they really were.

The next question was, what we should call the museum, and I suppose because I was the keen collector, the Min Lewis Perambulator Museum seemed appropriate.

The Old Manse itself is a museum piece, with its original seventeenth-century staircase, and the room which we decided to use for the museum has a fine plaster ceiling, depicting the coats of arms of Henry VIII and Catherine of Aragon.

As the prams accumulated, so the furniture was sold to make more room, and we found ourselves forced to sleep in the attic rooms. It became a joke, that the prams had taken over the house like an invading army and would eventually force us out altogether. I am glad to say that this was only a joke, but the invasion of the perambulators was a reality.

Ten of my prams, including a twin pushchair with chip carving on the sides, which Arnold selected, together with their occupants, were exhibited for the first time at "The Age of Innocence" exhibition at the Holburne Museum. The exhibition proved a great success, and through exhibiting my pram collection, I made many friends. It was there

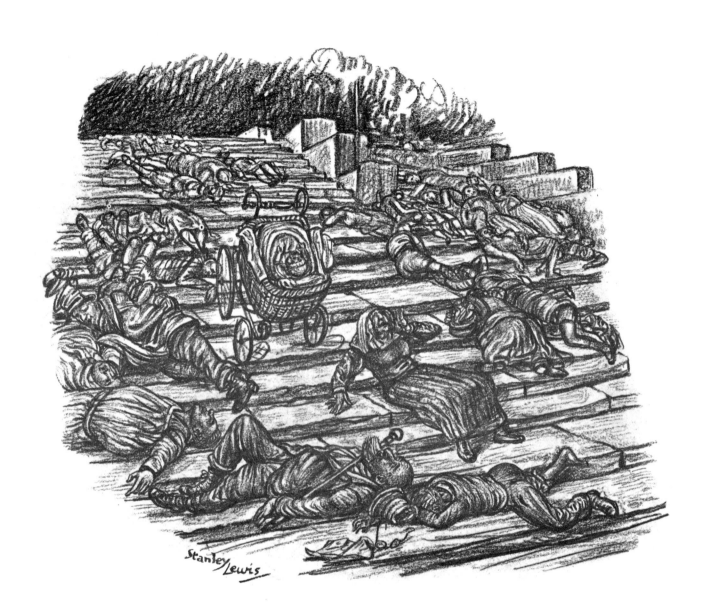

I was told that there had been a small pram museum in Yorkshire, but unfortunately when the gentleman who owned the collection died, the perambulators were sold. I am rather sorry I never met this gentleman as we would have had so much to talk about.

The perambulator has played many parts in history. From having once had a prestige status, many prams have been degraded by being used as a beggar's conveyance in which to carry his goods and chattels. While walking down Stow Hill to school, I remember seeing an old man and his wife using a perambulator as the means of transporting their wooden table-size gramophone. It had an enormous horn, and while the needle scratched out the tune, "Roses are blooming in Picardy", the old lady rattled a tin as she begged for pennies to be dropped into it. Then there was Old Charlie, an old man who pushed a pram around collecting old rags and bones, his familiar diction indistinct as he shouted, "Rags and Bones".

Apart from beggars, one recalls the many pathetic pictures of refugees fleeing from the terrors of war, pushing along their few belongings in old perambulators, or the setting in the film *The Battleship Potemkin* when the pram comes tumbling down the steps.

My search for prams brought me acute embarrassment not so long ago. I was walking along a street in Bath, when suddenly I espied a pram which I dated about 1895, parked outside a second-hand clothes shop. Naturally I began examining its finer points, and was just about to enter the shop to enquire its price, when out walked an aged man. He eyed me suspiciously, almost accusing me with his eyes of stealing his most prized possession, then he placed a small package in the pram, and gently pushed it away.

The situation was so unusual that I burst out laughing; that incident made my day, for my quest for prams had not only its serious side, but its comical aspect as well.

When I read this extract from Mr. Sewell's paper I was surprised:

As to the United States, the duty has been so much against us as to restrict imports, although the American pram is an inartistic, uncomfortable vehicle compared to our own. Formerly, its body was made of cane or other vegetable product, but of late years of wire, covered with a solution and woven by a machine constructed under Lloyd's patent. That class of pram, however, scarcely suits British tastes, yet it is made here at Lusty's factory in Bromley-by-Bow. But it is only fair to say that to America is due the invention in 1904 of an ingenious metal folding car, of which, before the war, many thousands came to this country. It was found, however, that these could be produced more cheaply in this country, and then firms opened factories in Birmingham and Leeds. Further, they made substantial improvements, notably Messrs. Headley, Baker and Giles, and we now not only supply ourselves but also export such metal folders.

When I read this extract I was greatly surprised, especially as the pride of my

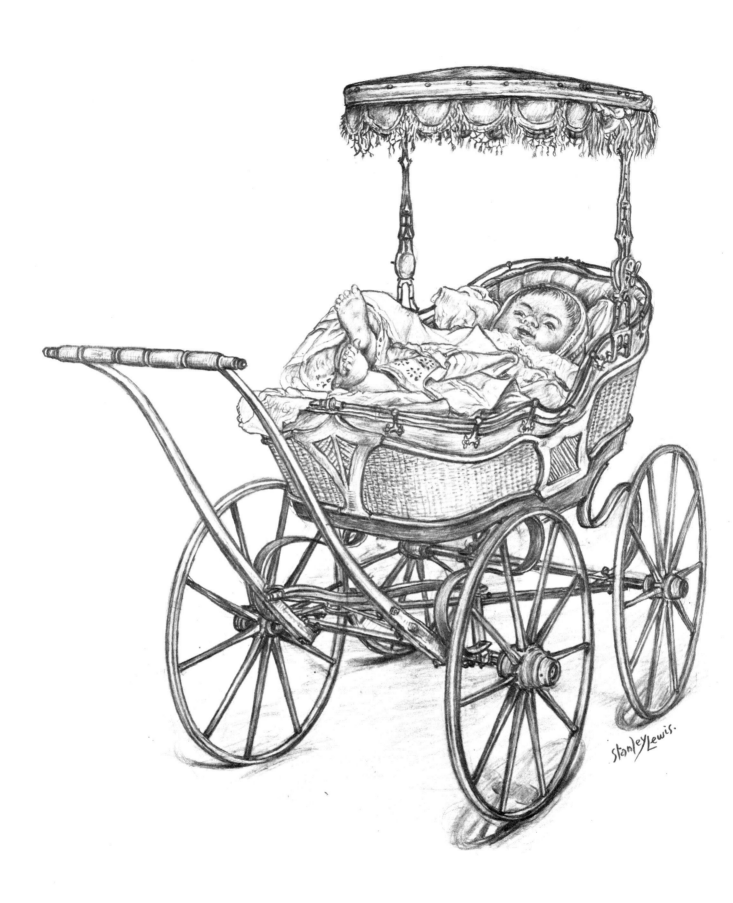

Stanley Lewis.

collection is an American baby carriage, which was probably brought to this country in the last century by an American ambassador. It is almost in perfect condition, which is surprising for its age and fragile appearance.

The London dealer from whom I purchased the American baby carriage, thought it was English and dated it as Regency, until someone disillusioned her. I like to think that this particular pram is a Crandall, dated 1860–1870, but of this I am not sure.

In my quest for information on American carriages, I received some useful information from the Shelbourne Museum, Vermont. Although the head of the research department admitted there was very little literature on the subject, she wrote: "We have a small collection of baby carriages on which practically no work has been done, so I do not know whether or not we have a Crandall."

Benjamin Potter Crandall was born in Hopkinton soon after 1800. His first shop was in Westerly, Rhode Island, where he sold baby carriages and some toys.

His first carriages, which were made of basswood with only two wheels and no real axle, were assumed to be the first baby carriages to be manufactured in America.

He had four sons, Jesse Armour, Benjamin Potter, Jr., Charles Thompson and William Edwin. The business prospered and progressed, and in 1841, Crandall moved the firm to New York, where very soon his sons began to help in the growing enterprise.

Marshall and Inez McClintock, the authors of the book, *Toys In America*, state:

Jesse started whittling things when he was about five years old, and at the age of eleven he was helping in his father's shop, boring ten holes in a wooden hub to take the spokes of the carriage wheels. Since all ten holes were exactly the same size and had to be evenly spaced, he devised a rig with ten bits, a combination of gears, and a single brace that enabled him to drill ten perfect holes at one time.

The Crandall carriage developed into an elegant four wheeled affair with springs and a fringed top, always being improved by new Crandall inventions. An oscillating axle was one of their greatest prides. As Jesse's nephew Charles, who was in the business as a young man, later said, "It was sixty years before the automobile industry adopted the principle of the front axle as developed on Crandall carriages".

He was no doubt referring to the independent suspension of each front wheel. Patent Office records state:

Crandall, Jesse A., patented a perambulator and child's carriage in 1861
Crandall, Benjamin Potter, patented new devices in 1867 and 1869.
Crandall, Benjamin Potter, Jr., patented in 1870 a combination sleigh and carriage.
Crandall, William Edwin, in 1870, 1871 and 1876.
Jesse had additional patents in 1870, 1871, 1873, 1874 and 1875, including one for what may have been the first folding carriage.

Benjamin Potter, Jr., took to the bottle and in time left the business and went away, to the great relief of the other members of the family. He died in Buffalo, but not prematurely of drink, for he outlived the majority of the family and lived to the ripe old age of 104 years!

Before the Civil War, the business occupied an entire block on Madison Street,

FIVE GREAT LEADERS.

BUT AT WHAT A PRICE!

Our $8.50 Baby Carriage.

Our $8.60 Baby Carriage.

Our New Fancy Hood Top Carriage for $10.25.

Our $10.50 Baby Carriage.

Our New Model $11.50 Carriage.

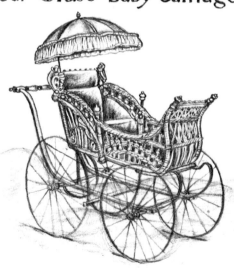

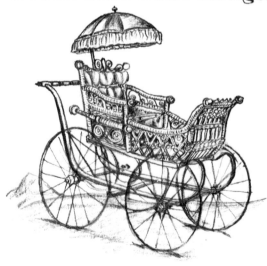

but there was a setback after the Civil War when the Crandalls failed to collect bills from the South. To make up for the loss of business, Jesse took a job teaching convicts how to make toys in the Ohio State prison.

On returning to New York, he found that his father and brothers Charles T. and W. Edwin had started the carriage and toy business again. Jesse set up business in Brooklyn, first at Fulton and Orange Streets, later at Fulton and Pierrepont.

The authors of *Toys In America* state:

The two family firms worked together for some time, advertised their wares together and overlapped on only a few items. Jesse concentrated on toys, but also made some carriages. His brothers concentrated on carriages, but also made some toys. (Benjamin Potter, the father, appears to have been inactive, or dead, after about 1870.)

The son of Charles T. Crandall remembered, when he talked to the authors of *Toys In America*, a good many details from the end of the nineteenth century.

He worked in the business for some years as all young Crandalls did. At the age of eighty-three, when he was, as he had been for many years, first select man of Mystic, Connecticut, he recalled that his father and Uncle W. Edwin had their business on Third Avenue, with a store on the ground floor and manufacturing on the floors above.

English-style carriages, with solid bodies, went out of style very suddenly, and reed or rattan carriages became the rage.

Fortunately, a broker bought up all the Crandall English-style carriages and shipped them off to South Africa, where the style had not changed.

Doll carriages were produced as well as baby carriages, and Wanamaker's store was their best customer for these.

I continued my search for American baby carriages, for I discovered that the Americans did not call them perambulators, and I wrote to an American friend asking her to look around for some vintage baby carriages. Her reply was:

I have looked at two very old baby carriages, but I believe they are not nice enough for you, also costly, and I am afraid they would not travel well. After I began enquiring, I was amazed at the dolls and old doll furniture and carriages etc., that were actually prized by people who appeared to take "the bread out of their mouths" to buy such things.

I got a re-print of Sear and Roebuck's old catalogue as you wrote about, but no item pictured is available now.

I must say I read the last paragraph with some misgivings, for the baby carriages advertised in their 1897 catalogue were, without doubt, works of art. Three or four pages were devoted to baby carriages, all made with reed but varying in design.

They were made up in a maple frame with a reed body and all except one had attractive scalloped parasols. The odd one out had a reed hood instead of a parasol. Catalogued as No 9930, for the Americans did not use the attractive names to describe

the individual carriages as the English did, this particular carriage was described as one of the most convenient, comfortable and durable carriages made. The advertisement continues:

> The hood can be removed when desired and will be found the best protection against sun and wind. It is adjustable to any position desired. This carriage is made from the very best material. The body is of the highest grade reed, elegantly finished fine Brussels carpet on bottom, has the very best bent wood handles, 4 steel springs, steel axles, steel braces, is fitted with the best self-locking automatic brake, upholstered in fine damask with plush roll. Extra charge for rubber tyred wheels.

What seemed to me so attractive about the American carriages was the way they were upholstered, some in genuine silk-damask, piped, beautiful plush silk pillows with silk cords and tassels, all in varying shades of blues, pinks, greens and other pastel shades. The parsols too were made of fine quality silk satin, lined, with flounced ruffles and valenciennes edges.

The higher the price the more luxurious the upholstery, for there was a prestige value in America as there was in England; a cheaper baby carriage would have a Brussels carpet in the bottom, would be upholstered in cretonne, buttoned, with a fancy scalloped edge silesia parasol.

When I see these carriages advertised in the old catalogues, I am reminded of the film *Gone With the Wind*, when Scarlet O'Hara pushes her child, Bonny, along the street. Oh, what a gay occasion it was, and what an attractive picture both she and the baby carriage made.

Yes, it must have been a fine sight to see either the mother or the nurse pushing one of these gay carriages, very grand in fact when the weather permitted. They might be termed fair weather baby carriages, quite unlikely to stand up to our stormy English climate. Is that why our perambulators were more solidly built with weatherproof hoods and aprons?

Glancing through an English catalogue, The Army and Navy Stores Catalogue of 1907, I could not help but comment on the fact that the American baby carriages would have looked even more attractive had they had the names instead of dull numbers.

The English perambulators read like poetry, *The Ideal Landau, The Cheltenham, The Windsor, The Canoe, The Cornwall* and *The Sandringham*.

All were upholstered in American leather cloth, mounted on C springs, and fitted with reversible jointed hood. The most expensive was *The Sandringham*, for it was constructed of best panelled wood body, upholstered with white American leathercloth, mounted on best C springs, reversible hood lined white, fitted with brass adjustable joint, 21 and 25 inches, tangent spoke bicycle wheels, with extra thick rubber tyres, brass handlebars, and clip brake, all for the price of £8.18.0.

In 1881, a trade magazine was founded called *The Journal of Domestic Appliances*. In the first edition there was no mention of perambulators, in 1882, half a column was devoted to the advertisement of prams, in 1883, there was no mention of prams, a few

appeared in the 1884 edition, but finally the journal became a pram supplement, to be known as *The Journal and Pram Gazette*.

There were two pages devoted entirely to perambulators and mail-carts in *The Hardware Trade Journal* of March 1900.

Simmons and Co., 3, 5 & 7, Tanner Street, London, S.E., was the firm who advertised their wares, and what fascinating names: *The Argosy*, *The Ideal*, *The Queen Mab*, *The European*, *The Park*, *The Elysian*, *The Ranee*, *The Darling*, *The Naiad*, *The Promenade*, *The European*, *The Luxury*, *The Ayah*, *The Delight*, *The Serpentine*, *The Nest*, *The Austrian* and *The Paragon*.

The mail-carts had names as well, *The Cosmopolitan*, *The Combination*, *The Universal*, *The Popular A*, *The Hindu*, *The Empire*, *The Popular C*, *The Mela*, *The Parsee A*, *The Protean*, *The Radiance*, *The Nurse*, *The Simmons Gig*, *The Beauty*, *The Welcome*, *The Parsee C*, *The West End*, and last but not least *The Zenana*.

Contained in the same journal was a page entitled, "The Workshop Review":

PERAMBULATORS AND MAIL-CARTS

Messrs. Simmons and Co., Tanner Street, S.E., are particularly well engaged at the present time in the production of a large number of new pattern mail-carts and perambulators. An inspection of their work reveals the fact that they not only cater well for the home and ordinary export trades, but they do a considerable trade with large firms in such cities as New York, Chicago, Philadelphia. The peculiar feature of this business is that in those designs where reed work comes into play, the worked up reeds are imported from the States. They are then made into complete carts and returned to the States. At the time of the visit now under record, the warehouse was crowded with large cases which were "off to Philadelphia in the morning".

The goods manufactured for the States are of a very special quality, and of a size much larger than those adopted in our own tight little island. There is, of course, a fashion in mail-carts, as in everything else pertaining to the feminine world. Just now decoration is playing an important part. At one time the useful but rather doleful blacks and other dead colours were in vogue. Now all that has changed. At the present time, fond mamas may be tempted to buy a mail-cart or perambulator with a navy blue body and red under-carriage, or with blue bodies and primrose under-carriages. Others again are adorned with navy blue bodies and ivory white interiors, whilst for those who like something perhaps more delicate still, a pure white exterior associated with a pale blue interior is offered. So the variations proceed, and everyone of them in the direction of finish remarkably gratifying to the eye. Patterns treated in this way are necessarily dearer than those of the ordinary finish, but there can be no question as to the additional value.

Lincrusta Walton bodies, introduced some little time ago, lend themselves well to effective treatment, and it is not surprising to learn, therefore, that there is still an excellent demand for bodies thus covered. There can be no doubt that some of the most handsome which Messrs. Simmons turn out are the reed body patterns, to which allusion has already been made. The Anglo-American may be accepted as a very typical specimen of this class of work, and when, as will be seen from the illustration (Fig 1) the cart possesses the advantages of the combination arrangement,

SIMMONS & CO., Wholesale Manufacturers

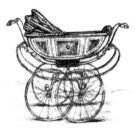 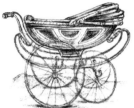 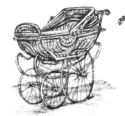 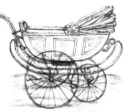

The "ARGOSY".　　The "IDEAL". (Registered)　　The "QUEEN MAB" (Reg.) American Reed-work.　　The "EUROPEAN".

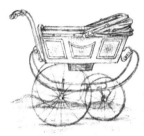 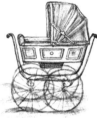 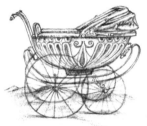 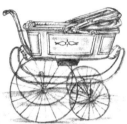

The "PARK".　　The "ELYSIAN".　　The "RANEE".　　The "DARLING".

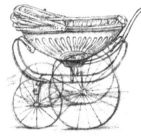 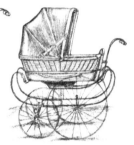 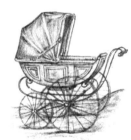 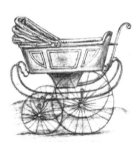

The "NAIAD". (Registered)　　The "PROMENADE".　　The "EUROPEAN" "OVOID" SPRINGS. (Registered)　　The "LUXURY".

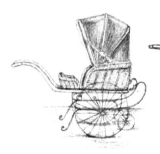 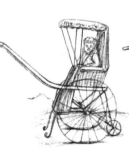 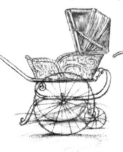 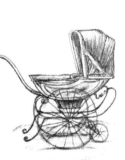

The "AYAH".　　The "DELIGHT".　　The "SERPENTINE". American Reed-Work　　The "NEST".

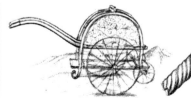 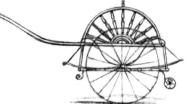

The "AUSTRIAN". (Registered)　　THOS. F. SIMMONS' PATENT HOOD JOINTS.　　The "PARAGON" (Registered)

Every Carriage Guaranteed Perfect, Artistic, and Durable.

3, 5, & 7, TANNER STREET, LONDON, S.E.

SIMMONS & CO.,

Wholesale Manufacturers

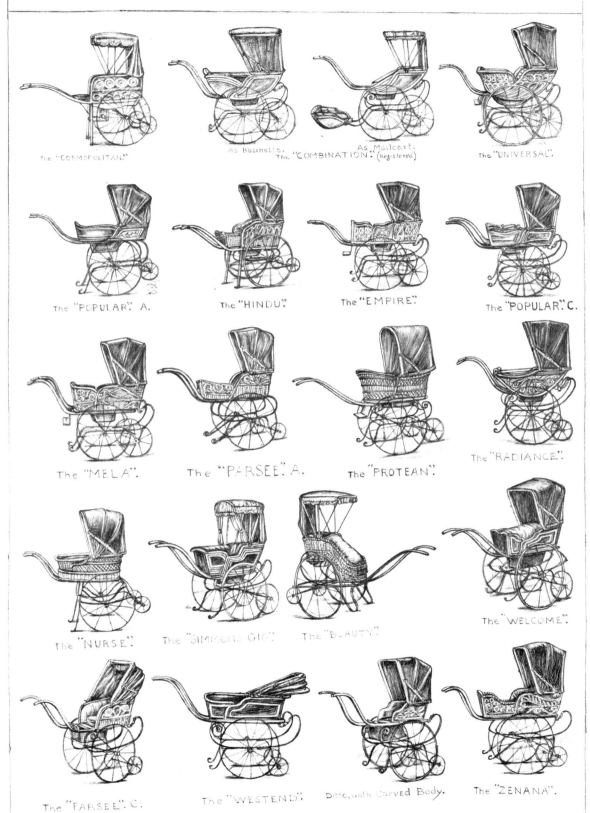

The "COSMOPOLITAN."

As Bassinette. The "COMBINATION." (Registered) As Mailcart.

The "UNIVERSAL".

The "POPULAR". A.

The "HINDU".

The "EMPIRE".

The "POPULAR". C.

The "MELA".

The "PARSEE". A.

The "PROTEAN".

The "RADIANCE".

The "NURSE".

The "SIMMONS GIG".

The "BEAUTY".

The "WELCOME".

The "PARSEE". C.

The "WESTEND".

Ditto, with Carved Body.

The "ZENANA".

which Messrs. Simmons introduced some little time ago, it will be acknowledged that the design will hardly fail to make its own way. The cane work bodies are produced at Tanner Street, a special department being established for this class of work. Some excellent patterns are turned out, and at prices which are bound to command attention. Amongst the newest designs in mail-carts are included the "Fay" and the "Radiance". The "Nest" is a very elegant shape, as will be judged from Fig 2, it is a handsome, well-balanced cart, easily driven, and of ample size for the comfort and convenience of the infantile occupant. Messrs. Simmons & Co. have adopted a plan in regard to show-posters, which ironmongers will appreciate. They have prepared some finely coloured posters upon which the local dealer's name can be printed. These posters are distributed without charge. For house to house distribution the firm have got out some well illustrated sheets, with names of the articles and retail price fully printed. These, like the posters, will be distributed to those who are prepared to make fitting and proper use of them.

I have searched in vain for a pram poster, but I still hope that one day I shall find one.

It seems that the ironmongers stocked prams in those days, and I suppose a pram shop was unheard of.

A pram I was pleased to find had wooden coach work with leather upholstery, twisted brass fittings and solid rubber tyres. The interesting thing about this perambulator, was a folding back-rest for a second child, the date c. 1900.

Not long ago, I wrote to Marmet Prams Ltd., asking for any information they could give me on the subject of prams; and I learned that the original company was registered on the 10th January 1913, so in all probability, the first Marmet perambulators were manufactured in 1912.

I also learned that the Marmet firm offered one of their very early baby carriages, in excellent condition, to the Victoria and Albert Museum, London, but it was declined.

About the same time, I wrote to Lawrence Wilson and Son, Ltd., makers of the famous Silver Cross perambulator. "The Silver Cross Story" was printed in the *Perambulator Gazette and Nursery Trader*, November 1964; and the article traces the beginnings of a successful perambulator firm.

In 1877, William Wilson, who began working life at the age of eight in a Sunderland sawmill, started business as a perambulator manufacturer at Leeds. The founder of the firm was 21 when he came to work in Leeds, as a perambulator springsmith, before launching into business on his own with small premises at Hunslet. He moved a few years later to the centre of the city, and again to even larger premises in Desbury Road.

A prolific inventor, William Wilson* held more than 30 patents, including those covering his improved double suspension hammock, folding shafts for mail-carts and convertible mail-carts. These inventions led to steady expansion. In 1897, a new factory was built in Whitehouse Street, Leeds. This was destroyed a year later by fire which brought the opportunity to rebuild it on a larger scale as the first Silver Cross works.

*It is worth noting that patentees of perambulators and feeding bottles seem to have been almost invariably men.

On the founder's death in 1913, the business was carried on by his three sons, Alfred, James, and W. Irwin Wilson. The present managing director, Lawrence Noble Wilson, is the nephew of Alfred Wilson, and worked closely with him and his own brother, William Noble Wilson, until their deaths.

The successful story of this firm is fantastic, for they now produce as many perambulators in a fortnight as were made during a year in 1936 when the present premises, which was an old silk mill, was purchased.

From this factory, probably the most expensive pram ever was exported, described as "A pram to top all prams, with gold-plated wheels and spokes, 22 carat gold strips on the side and calfskin hood and apron, with navy satin lining, trimmed with real mink". It must rank with Lady Docker's famous Daimler!

The pram was flown to Lawrence Wilson's agents in New York, Best and Co., of Fifth Avenue, who wanted a very special pram. The cost was no object, so the pram to top all prams was designed to attract big crowds to the New York store. The pram was not made for anyone in particular nor for any special occasion in the store, it was simply part of a general sales policy of promoting something special.

All the fittings which are normally chromium plated, including the wheels and spokes, were plated in 22 carat gold. An added attraction was a musical box which played an Austrian lullaby incorporated into the body. The price of this very special pram was £300.

An earlier pram produced by Pedigree in 1951, was a low built carriage, almost in the shape of a lawn-mower, the wheels were small with thick tyres, and it featured a "lullaby box", which played a famous lullaby at the turn of a key.

A pram with gold-plated wheels and spokes, with a musical-box, sounds like a new innovation; but in fact, as early as 1883, a bassinette pram with gold-plated springs, a musical-box under the seat, was made for an Indian prince.

As perambulators are manufactured for mothers to push their babies about in, we wonder whether women have any ideas for a perfect perambulator.

In February 1934, a woman's magazine called *Wife and Home* traced the progress and history of baby's car, as they described it, how it was invented and improved, and offered the substantial sum of £10 for suggestions towards designing the *Wife and Home* Ideal Pram.

I quote from this article:

Of course, as the years went by, and the pram developed, all kinds of improvements were invented, some successful and some not!

There have been many inventions in the way of "convertible" prams, ingenious devices for using the pram boldly as a cradle, a bath, a trolley, and even a swing-boat!

A patent taken out in 1903 was for a kind of hammock that could be attached to the side of the pram to accommodate a second baby, and it is curious that this is said to be the only patent in connection with prams ever taken out by a woman.

There seem to have been many patents taken out for handles. In 1881, Dunkleys patented a reversible pram. The handle was hinged to the middle of the under-carriage,

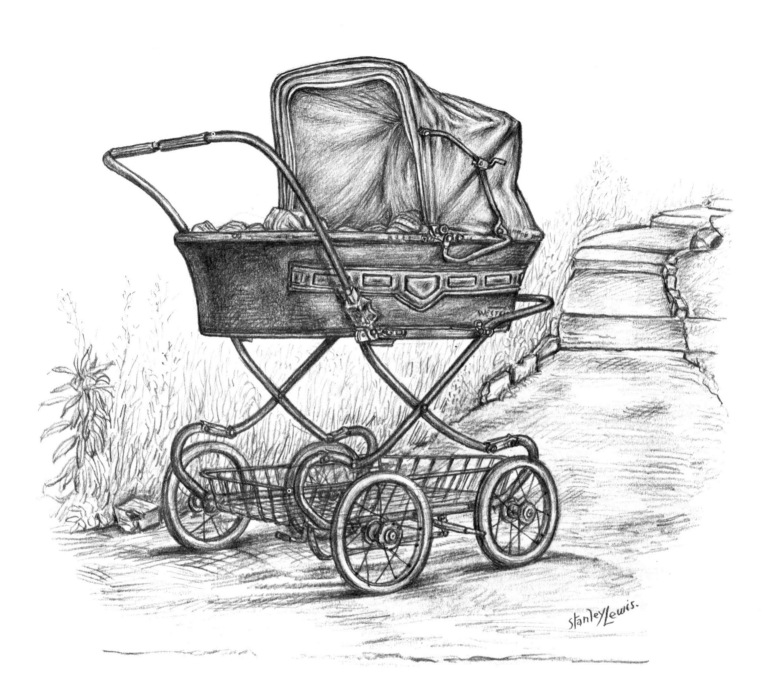

and swung round to either end. A bassinette pram, patented in 1883, was supplied to the Royal Family. It was steered by two horn handles.

Many inventions were obviously too outrageous to be practical, and, as is usually the case, it was the simple devices that were the most useful and successful.

One simple invention was made to overcome rain that collected in pools on the apron. A shape was devised so that the apron, when fastened tightly to the hood, formed a ridge that shoots the water off to either side.

From 1850 onward many patents were taken out, and there were great improvements made in springing, upholstery and for the general comfort of the occupant.

In 1914, ball-bearing wheels were introduced, and at that time cost £4 extra.

Deep-bodied prams with small wheels appeared after the first world war and, at the time, these were thought to be safer and warmer for babies and young children. However, it was soon thought that too great a depth of body kept the air from a baby, so the designs reverted to those of the earlier prams again.

The early prams were based on the designs of the coaches and carriages, then, when motor cars were invented, the perambulator design was based on the latest car.

In the late 1920's, Mr. Walter Lines, founder of Lines Bros., Ltd., revolutionised the pram industry by manufacturing prams with steel bodies, so for the first time in the history of prams, quality prams could be mass-produced at popular prices.

Other firms who at first nicknamed the new Pedigree prams as "Tin-cans on wheels", soon retracted their words, and shortly afterwards steel bodies became standard.

The first metal-bodied prams had very deep bodies and very small wheels with thick tyres, and the best included chromium-plating. Today, bodies have become shallow and more streamlined, and there is far greater emphasis on suspension.

The navy, green, black or white American leather cloth used for the upholstery has been replaced by modern fabrics such as PVC and brushed nylon in brighter colours and patterned fabrics.

Elegant coach-built prams are still to be seen today, but the majority of young mothers seem to favour the soft-bodied folding pram, much more convenient of course for people living in high flats, and for conveying in a motor-car.

While reading the evening paper recently, I was pleased to notice that perambulators still have names. The one I saw advertised was called *The Minster*.

Three points were emphasised:
1. Full bedlength, fitted with backrest and adjustable footrest.
2. The body is detachable and thus, at a later stage reversible.
3. Tailored in ribbed nylon fabric or vinyl.

Colours: French navy, with navy lining and red, turquoise, lilac or plain panel flash, red with navy panel.

The price, £17.19.6 only.

Unlike its ancestor, the modern pram is no longer a status symbol; for gone are the leisurely years when nursemaids pushed their charges in the parks, and flirted brazenly with the soldiers in their gay red uniforms.

It is a fact that the style of the modern pram is dictated by the difference in climate between North and South.

There is the infinitely graceful and essentially practical high shallow brightly-coloured pram seen in Italy, with its frilly curtains in the middle of which there is a

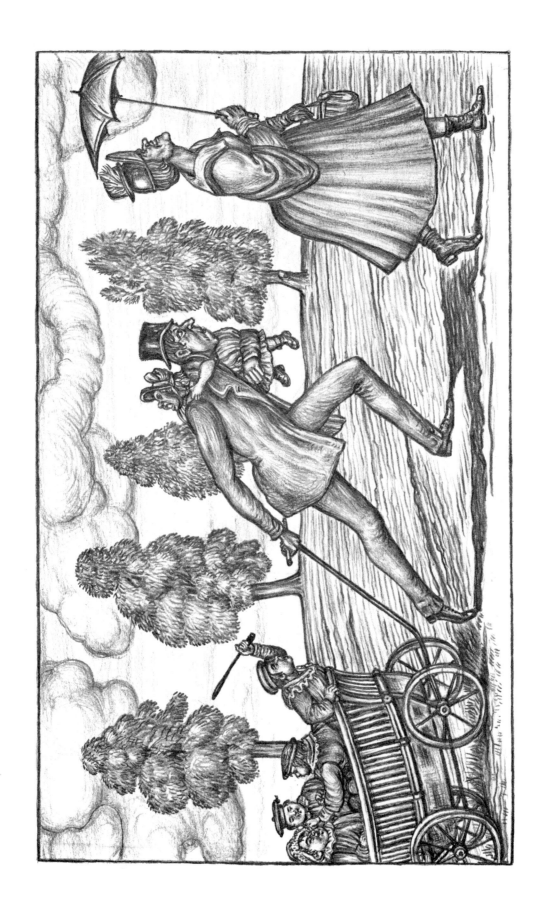

plaque of the protective madonna, and its miniature parasol, like that of a Victorian damsel, that can be slanted in any direction. These prams, surrounded by adoring parents and grandparents, are a conspicuous feature of any open air café from midday to midnight.

Then there are the deeper, sturdier and more soberly-coloured prams for northern climes, babies invisible under a mound of coverings and protected by a plastic windscreen. The English pram, like the English weather, is a judicious compromise.

As far back as 1895, a pram was invented that could be lifted off its undercarriage and used as a cradle, and although it was a "bassinette" type, it had a well which remained on the undercarriage.

What is the Ideal Pram?

Everyone has his or her ideas, some favour high prams, others prefer low vehicles, but it seems that Dr. Eric C. Pritchard, who was a specialist in children's welfare for years before 1923, summed up his theory in just a few paragraphs.

Until seven or eight months, a child should be allowed to lie down in its pram, after that the child should be induced to sit, hence the necessity of a well.

The body of the pram should be upholstered to provide comfort, and the material used should be of such a nature that it can be easily cleansed. As to the springs, these should be so elastic that no shocks or jars are conveyed to either infant or mother, and the body should be so attached to the chassis that the pram cannot be overturned by the child.

Lastly, the pram should be easy for the mother to propel, and it is eminently desirable that a brake be provided and that this be automatic.

There were rare cases of a pram running away and the occupant being killed by a fall-out, and so automatic brakes sounded the ideal means of controlling a perambulator, but the general public did not favour them, for the system was too difficult for many people to manage, as it meant holding off the brake when the carriage was wheeled by a lever or cord.

Then someone invented a clip for the wheel which proved satisfactory, but was not automatic.

There were many patents taken out for springs, and of course the name of the inventor who introduced the first metal-spring used for the baby carriage made for the Duke of Devonshire in 1730 is unfortunately not recorded. Again, the second carriage made for the same family in 1784 had springs, but again the inventor's name is not recorded.

More than fifty years had to elapse before the first patent for springing was introduced by W. C. Fuller in 1855; he used India Rubber, and in 1856 Johnson coiled a flat strip of steel into a circle, using two springs, so that one was elongated whilst the other was contracted.

Patent followed patent, and in 1887 Simpson, Fawcett & Co. introduced the hammock-carriage, suspending the carriage from two handles.

The same year, C. Thomson patented C springs, and his might have been the most important patent in the history of pram manufacture had he thought of a lower suspension, and provided for it.

In 1916, W. H. Dunkley took out a patent for C springs using a low suspension by supporting the body so that it could be brought nearer the ground than formerly. The next invention was the coil-spring to support the body. Conical in shape, the spring allowed elasticity in every direction.

Child comfort was not considered very important until 1884, when Sanders brought out the first patent for head rests; but sanitary devices had never been a success.

In 1883, E. Sandow brought out the first patent for a "medicated medium", and a ventilating fan driven by clockwork. Other proposals which did not catch on were for detachable upholstery.

There were so many patents brought out, but few were of real value.

In 1903, Schaefer patented a baby-carriage with a folding-seat for the nurse, and in the same year, Feld applied to the carriage a feeding-bottle receptacle!

The types of materials used for pram bodies are varied and numerous—soft, hard and veneered wood, wicker, cane, papiermâché, reed, wire gauze filled with composition, stamped sheet metal, celluloid, vulcanised rubber, cloth and steel.

Once there was an order that red and white lights be affixed to prams, but this was never adhered to.

Many inventors thought to mechanise the pram. As early as 1769, Francis Moore proposed to use "fire, water or air", but as he did not record any details, it is not known how he intended it to work.

In 1869, Chambers used cranks on the front wheel of a three-wheeler, and in 1888, Plant and Brown fitted a spring motor to a pram.

In 1889, Garvey used a hand lever in combination with a crank. In 1892, Schreiger produced a pram which was propelled by the child alternately sitting and standing.

More recent methods were an electric motor made by Carters, and a pram with a petrol motor made by Dunkley in 1921. The latter was constructed to accommodate the nurse as well as the baby. The cost of such a vehicle was £100, which was far more than most people could afford, but it was not only the price that deterred people from buying, but the fact that such a pram would not be allowed on the footpath, and would require a road licence if used on the road.

Somehow, the thought of a mechanised pram is not appealing, except perhaps as a novelty, for the humble, gentle pram is meant to be pushed and denotes a leisurely outing to the park or shops.

I have searched in vain for a mechanised pram to add to my collection, perhaps somewhere there is one hidden away in someone's attic?

Through catering to passing whims and fancies, many firms lost money and were left with unsold stock, however, taking all in all, through all their strife and tribulations, pram makers were long lived, and so were their work people.

In 1923, Mr. S. T. Fawcett, of Simpson, Fawcett, the grand old man of the trade, was over ninety, and Mr. Simmons was over seventy, and many of the workers in the factories had worked for their firms for more than forty years.

Few made even small fortunes, although British wheels, tyres, fittings and canopies were famed, and there was a great exporting trade in these. No other country of the world could equal the pram industry of Great Britain.

Germany tried to sell prams to Britain, but the designs and the prices were unsatisfactory.

France mainly imported prams from Britain, until she started copying the English designs towards the end of the nineteenth century. We had, however, imported bassinette bodies from France to assemble on wheels in this country.

It is true to state that we have led the world in perambulators. At one time, perambulators were mainly sold through catalogues, but rumours circulated saying that those who sent out the best illustrated catalogues made the worst prams. This of course could have been sour grapes!

Samuel J. Sewell stated that:

"Mewling and puking in the nurse's arms", neither good for the infant nor the nurse, is now unnecessary. Secondly, that the pram has had seven stages, as follows:

1. At first a mere board on two wheels, to push or pull.
2. Then a simple lattice of wood on four wheels, which could be drawn.
3. And then a mere box drawn on four wheels.
4. Then a thing of beauty on four wheels, with springs, which, too, was drawn.
5. And then a wicker body, springless, with handle still in front.
6. The sixth stage, a thing on three wheels, pushed from the back.
7. Last stage of all that ends this eventful history. A pram on four wheels, to push, artistic, buoyant, inexpensive, sans shocks, sans danger, sans everything undesired. A feast to the eye, a pleasure to child and nurse.

In 1923, Mr. S. Dunkley, a perambulator manufacturer, whose firm produced the Dunkley mechanised pram, recalled his first memory of a baby carriage that was made by the village blacksmith:

It was like two steel fire guards put together with a well very much like that today. That was made in Warwickshire, a few miles from Stratford-on-Avon, and he remembered that when his mother had been gleaning and he was being brought home in the baby carriage from the harvest field, the corn that had been gleaned was sticking into his face as he sat in the pram.

To the question about the origin of the name "bassinette", he replied:

At one time, I can remember my firm buying English wicker cradles which were fixed on an undercarriage, but afterwards they bought the French bassinette because it was closer woven and very much nicer. I wonder whether that is where the name "bassinette" comes from? It was a name used in the workshops.

Regarding the order for red and white lights to be affixed to prams, Mr. Sewell stated:

The fines which might have been inflicted to date, should the police have cared to act, would, I estimate, pay off our national debt!

In the history of perambulators, there must have been a vast number of dis-illusioned inventors. Several inventors constructed prams which could easily be converted into sledges, ideal for snowbound countries, I should think.

In 1908, an inventor called Fleischmann introduced a pram with one wheel, the child reclining in a hammock, and in 1891, Outram introduced a mail-cart with removable seats, so that it could be used to carry parcels.

In 1908, an inventor called Kriz introduced a folding pram that could be carried in a carpet bag.

Very many inventions were completely useless and were never adopted. To be fair, however, the perambulator manufacturers have always been willing to experiment with any useful devices patented; but for all that, the shape and proportion of the perambulator has not changed very much through the years.

I am sorry that the mail-cart went out of fashion so soon, as the mail-carts in my collection vary in shape and construction quite considerably.

One mail-cart I particularly like has a rolltop device for an apron, similar to a roll top desk, quite ingenious of course but an idea that never caught on for, no doubt, not only would it be a temptation for a child to play with and easily break, but a dangerous device for a child's small fingers.

There can be no conclusion to the history of prams, and one wonders what the perambulator will look like a hundred years from now, but if I had to choose from the perambulators I have written about, I think my favourite period is between A.D. 1880 and 1890. The pram at that period might not have been the safest, nor have had the best springing, but in elegance, shape and style was extremely well proportioned and artistic.

Since that memorable Christmas morning when I first saw my doll's pram, I have been fascinated by these wheeled vehicles, as most females are, I suppose.

My first born, having entered a world at war, had to be content in a secondhand soft-bodied folding pram with chromium mudguards and fittings, while my second child, born the year the war with Europe ended in 1945, was content in a coach-built utility pram which sufficed for her brother born a year later. At this period in the history of prams, owing to a shortage of necessary materials, prams were produced with the minimum of extravagance and were called "utility".

The perambulator I bought when my daughter was born was austere and of course devoid of any decoration, but still there was a certain charm about it, and I thought it very fashionable as I pushed it down the hill to Carmarthen town. At that time it was the height of fashion, and is now a part of the history of the last world war. Fashion changes so quickly, for what is fashionable today is out of date tomorrow, but perhaps through all the changing fashions, the perambulator has and will remain fundamentally the same.

Since becoming a perambulator enthusiast my collection has reached the necessary number for the start of an interesting pram museum. These prams all have occupants, large bisque dolls dressed in suitable costumes, and an addition to my small museum is a Victorian nursery, with a cradle, a gaily coloured picture screen, toys and a pram! There one can feel the warmth, contentment, and nostalgia of a bygone age.

Bibliography

A descriptive account of the history of prams for the collector is "The History of Children's and Invalids' Carriages" by Samuel J. Sewell, printed in the *Journal of the Royal Society of Arts,* 7th September 1923, to which I am indebted.

My thanks also to Mr. G. B. L. Wilson, assistant keeper at the Science Museum in South Kensington, London, and to Miss Thatcher at the Science Museum. To the Shelbourne Museum, Vermont, U.S.A., and to Mr. Michael Masters who has shown such enthusiasm for my pram collection. Also to all my acquaintances who have helped me find so many prams and to those who have sent me early photographs of prams, and coloured postcards, and especially to Arnold L. Haskell and Dr. Mary Holbrook for exhibiting my pram collection at the Holburne Museum, Bath, in "The Age of Innocence" exhibition, Christmas 1969.

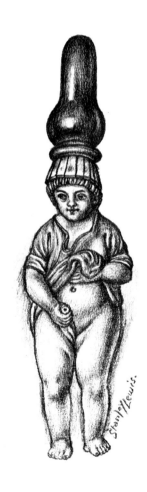

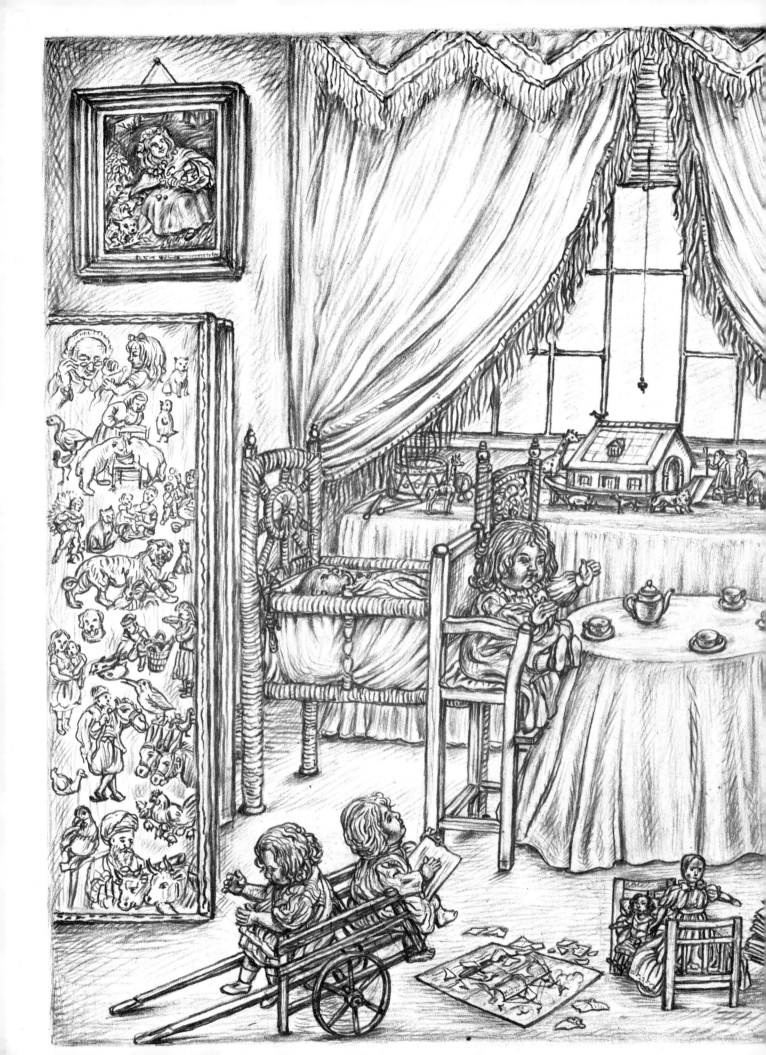